Ruskin and Turner

Ruskin and Turner

A study of Ruskin as a collector of Turner,
based on his gifts to the University of Oxford;
incorporating a *Catalogue Raisonné* of the
Turner drawings in the Ashmolean Museum

LUKE HERRMANN

FABER AND FABER
24 Russell Square
London

First published in mcmlxviii
by Faber and Faber Limited
24 Russell Square London WC1
Printed in Great Britain by
R. MacLehose and Company Limited
The University Press, Glasgow
All rights reserved

SBN 571 08497 4

To
GEORGINA

Contents

FOREWORD *page* 11

LIST OF ILLUSTRATIONS 13

LIST OF ABBREVIATIONS 17

RUSKIN AS A COLLECTOR OF TURNER
 DRAWINGS: with special emphasis on his gifts to
 Oxford University 19

TURNER AS A DRAUGHTSMAN: a survey based on
 his drawings at Oxford 43

CATALOGUE OF THE TURNER DRAWINGS IN
 THE ASHMOLEAN MUSEUM 53
 The Oxford Almanack Drawings 55
 Drawings presented by John Ruskin in 1861 64
 Drawings in the Ruskin School Collection 86
 Drawings from miscellaneous sources 102

PLATES *after page* 108

9

Foreword

The idea of devoting a special volume to the drawings by J. M. W. Turner at Oxford was initially suggested by Dr. Kurt F. Pantzer, of Indianapolis, on his first visit to the Ashmolean Museum, in the summer of 1961. Since then I have had several further stimulating meetings and discussions with Kurt Pantzer, each of which has added to my admiration for his knowledge of, and enthusiasm for, the drawings and prints of Turner, of which he himself has built up a notable collection. The publication of this book in its present form has been made possible by the generous subsidy given by Dr. Pantzer; to him and to his wife I extend my warmest gratitude.

Numerous other people have helped in the work on this book; some of these are acknowledged at the appropriate places in the text and catalogue. Sir Karl Parker and Mr. Gerald Taylor, by their previous work, provided the framework on which the majority of the catalogue entries are based, but the conclusions now put forward are entirely the responsibility of the present compiler. My thanks are also due to many others at the Ashmolean Museum, especially to the Librarian, Mr. R. F. Ovenell, Mrs. C. A. Gunn of the Western Art Library, Miss O. M. Godwin and Mr. M. R. Dudley of the Photographic Studio, and, of course, to all my former colleagues in the Department of Western Art. Miss Susan Diaz typed the whole manuscript with great efficiency. Mr. Hugh Macandrew read through the typescript and made many most valuable suggestions and corrections, for which I am truly grateful.

In my work on the drawings of the Turner Bequest in the Print Room at the British Museum I received most willing assistance from the Keeper, Mr. E. Croft-Murray, C.B.E., and from several members of his staff, especially Messrs. R. Williams and R. Ralph. I am similarly indebted to Mr. Malcolm Cormack of the Fitzwilliam Museum, Cambridge, and to Mr. Francis Hawcroft, Keeper of the Whitworth Art Gallery, Manchester. Major le G. G. W. Horton-Fawkes, O.B.E., has kindly answered several questions connected with Farnley Hall, and Mr. Evelyn Joll has made available the remarkable Turner records of Messrs. Thos. Agnew and Sons. The Ruskin

FOREWORD

Master of Drawing has put the relevant archives of the Ruskin School at my disposal. The Curator of the Museum of the History of Science at Oxford assisted me in my researches in connection with the drawing of the Old Ashmolean.

I have greatly enjoyed working on the detailed cataloguing of the Turner drawings while on the staff of the Department of Western Art at the Ashmolean Museum. I wish to thank the Visitors of the Museum for sanctioning the publication of this catalogue in its present form; the drawings are reproduced by their permission.

L.H.

Illustrations

All the drawings listed in the Catalogue are reproduced, four of them in colour, forty-one as whole-page monochrome plates, and the remainder in monochrome on a much smaller scale, for reference purposes. The series of whole-page plates is arranged as far as possible in chronological order: this does not relate to the catalogue numbers of the drawings. The same system has been followed in the seven reference plates (Nos. XLII–XLVIII).

COLOUR PLATES

A. 4. 'A View of Worcester College, &c.'. *facing page* 24

B. 76. Sunshine on the Tamar. 32

C. 50. 'Scene on the Loire' (near the Coteaux de Mauves). 40

D. 57. Venice : the Accademia. 48

MONOCHROME PLATES
after page 108

I 90. 'The Remains of Abingdon Abbey now called Starve Castle Abingdon'.

II 59. Boats on a Beach.

III 60. The Ruined Abbey at Haddington.

IV 65. Durham Castle from across the River.

V 91. 'Transept of Tintern Abbey, Monmouthshire'.

VI 64. Mountain Landscape with a Bridge.

VII 1. 'South View of Christ Church, &c. from the Meadows'.

VIII 3. 'Inside View of the East end of Merton College Chapel'.

IX 7. 'Inside View of the Hall of Christ Church'.

X 5. 'A View from the Inside of Brazen Nose College Quadrangle'.

ILLUSTRATIONS

XI 6. 'View of Exeter College, All Saints Church &c. from the Turl'.

XII 8. 'A View of Oxford from the South Side of Heddington [*sic*] Hill'.

XIII 71. Study of a Group of Cows.

XIV 12. Eton College from Fifteen Arch Bridge (on the Slough Road).

XV 72. Distant View of Lowther Castle (Park Scene).

XVI 75. Study of Trees.

XVII 77. A Frontispiece (at Farnley Hall).

XVIII 79. The Junction of the Greta and Tees at Rokeby.

XIX 24. 'Comb Martin' (Devonshire).

XX 80. Sketch of Mackerel.

XXI 23. (?) Yarmouth, Norfolk.

XXII 82. Scene on the Loire.

XXIII 32. Tancarville.

XXIV 33. Calm on the Loire (? near Nantes).

XXV 34. The Bridge at Blois : Fog clearing.

XXVI 36. The Bridge and Château at Amboise.

XXVII 35. 'Château of Amboise'.

XXVIII 27. Scene on the Meuse.

XXIX 44. 'Palace at Blois'.

XXX 41. 'Coteaux de Mauves'.

XXXI 42. 'Blois'.

XXXII 47. 'Beaugency'.

XXXIII 46. 'Tours'.

XXXIV 49. 'Rietz, near Saumur'.

XXXV 54. 'Mount Lebanon and the Convent of St. Antonio'.

XXXVI 29. 'Nantes' (Vignette).

XXXVII 52. 'Santa Maria della Spina, Pisa' (Vignette).

XXXVIII 56. Venice : the Grand Canal.

XXXIX 58. Venice : the Riva degli Schiavoni.

XL 84. On the Rhine : looking over St. Goar to Katz, from Rheinfels.

XLI 86. Evening : Cloud on Mont Rigi, seen from Zug.

ILLUSTRATIONS

XLII A 61. Old Shops in Chester.
 B 89. The Old Ashmolean with Scaffolding erected against its South Front.
 C 62. Old Houses in Chester.
 D 66. Coast of Yorkshire, near Whitby.
 E 70. Dunblane Cathedral.
 F 67. Solway Moss.
 G 68. Sketch of Clouds and Hills at Inverary.
 H 92. Coast View with Chalk Cliffs.
 I 69. Scarborough.

XLIII A 88. Craig-y-foel, Radnorshire.
 B 63. Bergamo.
 C 9. 'Part of Balliol College Quadrangle'.
 D 10. 'View of the Cathedral of Christ Church, and Part of Corpus Christi College'.
 E 2. 'A View of the Chapel and Hall of Oriel College, &c.'.
 F 93. Chester Castle.
 G 13. The Cloisters, Eton College.
 H 14. Barnes Pool, Eton, with Baldwin's Bridge.

XLIV A 18. Two Views on the Thames, near Eton.
 B 11. Two Views of Eton College.
 C 19. Two Views on the Thames, near Eton.
 D 17. A Sluice on the Thames near Eton.
 E 21. A Stable Yard with a Cart in Centre.
 F 20. The Hulk of a damaged Sailing Boat.
 G 16. A Punt moored in Barnes Pool, Eton.
 H 15. Barnes Pool, Eton.
 I 22. A Road shaded by large Trees.

XLV A 73. Distant View of Lowther Castle (Park Scene).
 B 74. Lowther Castle.
 C 78. Sketch of Pheasant.
 D 81. Study of Fish.
 E 25. 'Boscastle, Cornwall'.
 F 26. 'Margate' (Kent).
 G 55. 'Jericho'.
 H 87. Arcades of St. Peter's, Rome (after Turner).

ILLUSTRATIONS

XLVI A 28. Coast of Genoa.

B 30. Harfleur.

C 31. 'Between Clairmont and Mauves'.

D 37. Angers.

E 38. 'Amboise'.

F 39. 'Château Hamelin, between Oudon and Ancenis'.

G 40. 'Montjen'.

H 43. 'The Canal of the Loire and Cher, near Tours'.

XLVII A 45. 'St. Julian's, Tours'.

B 48. 'Orleans'.

C 51. 'Château de Nantes'.

D 53. 'The School of Homer, Scio' (Vignette).

E 83. On the Rhine.

F 85. Cloud and Sunlight at Sea.

XLVIII A 98. The Pyramid of Caius Cestius, Rome (Monro School Copy).

B 97. The Entrance to the Amphitheatre at Capua (Monro School Copy).

C 96. 'In the Grisons' (Monro School Copy).

D 95. A Villa between Florence and Bologna (Monro School Copy).

E 94. Corpus Christi and Merton College Chapel (attributed to Turner).

F 99. Saltwood Castle, Kent (formerly attributed to Turner).

G 100. Parkland, Autumn (formerly attributed to Turner).

H 101. Landscape with a white Horse and Haystack (formerly attributed to Turner).

List of Books
Referred to in Abbreviated Form

Bell and Girtin C. F. Bell and Thomas Girtin, *The Drawings and Sketches of John Robert Cozens*, in *The Walpole Society*, Vol. XXIII (1934–1935).

Diaries *The Diaries of John Ruskin*, selected and edited by Joan Evans and John Howard Whitehouse; 3 Volumes, 1956, 1958 and 1959.

Finberg, Life A. J. Finberg, *The Life of J. M. W. Turner, R.A.*; Second Edition, 1961.

Inventory A. J. Finberg, *A Complete Inventory of the Drawings of the Turner Bequest*: etc.; 2 Volumes, 1909.

Rawlinson W. G. Rawlinson, *The Engraved Work of J. M. W. Turner, R.A.*; 2 Volumes, 1908 and 1913.

Rawlinson, Liber W. G. Rawlinson, *Turner's Liber Studiorum*, 1906.

Works Library Edition of *The Works of John Ruskin*, edited by E. T. Cook and Alexander Wedderburn; 39 Volumes, 1903–1912.

Ruskin as a
Collector of Turner Drawings

'The pleasure of one's own first painting everybody can understand. The pleasure of a new Turner to me, nobody ever will, and it's no use talking of it.' These words from *Praeterita*[1] help to explain why Ruskin in all his voluminous writings devoted so little space to discussing his collecting of the works of Turner. Even in his Diary, which was a personal document, there are barely a dozen brief references to his collecting activities. Yet there is ample proof that Ruskin was a most assiduous collector of Turner's work; in Index I of Volume XIII of the *Works — List of Pictures, Drawings, Sketches and Studies by Turner at any Time in the Collection of Ruskin —* Cook and Wedderburn brought together 276 items, amounting to over 300 drawings in all. Ruskin gave as much as a quarter of this total — seventy-seven drawings — to the University of Oxford, and the detailed study and catalogue of these will, it is hoped, provide some insight into Ruskin's activities as a collector of Turner.

The first Turner water-colour given to Ruskin by his father, in about 1837 — 'not for a beginning of Turner collection, but for a specimen of Turner's work'[2] — was *Richmond Bridge, Surrey*, which had been engraved in 1832 in the series, *Picturesque Views in England and Wales*. This was joined two years later, in the autumn of 1839, by the *Gosport* from the same series. Both these drawings were included in the 1878 Exhibition of Ruskin's Turners (Nos. 33 and 37), and in his catalogue note Ruskin referred to the *Gosport* as 'among the last I would willingly part with'.[3] A third water-colour from the *England and Wales* series, the *Winchelsea*, was given to Ruskin in 1840 as a twenty-first birthday present, and it hung in his rooms at Oxford. In both the 1878 catalogue and in *Praeterita* Ruskin was somewhat critical of this drawing — 'I was disappointed,' he wrote, 'and saw for the first time clearly that my father's

[1] Vol. II, Chap. IV, para. 82; *Works*, XXXV, p. 319.

[2] *Praeterita*, Vol. II, Chap. I, para. 12; *Works*, XXXV, p. 254.

[3] *Works*, XIII, p. 440.

joy in Rubens and Sir Joshua could never become sentient of Turner's micro-scopic touch. But I was entirely grateful for his purpose, and very thankful to have any new Turner drawing whatsoever; and as at home the "Gosport", so in St. Aldate's the "Winchelsea", was the chief recreation of my fatigued hours.'[1]

These three drawings were all purchased from the dealer, Thomas Griffith, of Norwood, who was at that time Turner's regular agent for the sale of his works and who, in 1840, introduced the young Ruskin to Turner. The fourth Ruskin Turner — *Harlech*, from the same series — was entirely the son's choice, and the high price he unhesitatingly agreed to pay for it horrified the elder Ruskin. The episode is movingly recorded in *Praeterita*: 'It was not a piece of painted paper, but a Welsh castle and village, and Snowdon in blue cloud, that I bought for my seventy pounds.'[2]

Ruskin's 'love of Turner' was becoming a focal point of his life, and at the end of 1840 he wrote in a letter from Rome to his Christ Church friend, Edward Clayton: 'He [Turner] is the epitome of all art, the concentration of all power; there is nothing that ever artist was celebrated for, that he cannot do better than the most celebrated. He seems to have seen everything, remembered everything, spiritualised everything in the visible world; there is nothing he has not done, nothing that he dares not do; when he dies there will be more of nature and her mysteries forgotten in one sob, than will be learnt again by the eyes of a generation. However, if I get to Turner I shall get prosy. . . .'[3] The first volume of *Modern Painters*, Ruskin's monumental defence of Turner, was published in 1843; among the drawings discussed in it were a number which already belonged to Ruskin. With the material at present available it is extremely difficult to be at all precise as to when and where Ruskin acquired the bulk of his Turner drawings. In one or two instances, on the other hand, the story is relatively complete, and this applies particularly to the so-called 'Sunset' drawings, of which ten were executed by Turner in 1842 and five in 1843, and sold through Griffith.

In the *Epilogue*[4] to the *Notes* on the 1878 Exhibition of his drawings by Turner, Ruskin recounts in detail the commissioning and execution of these fifteen water-colours of Swiss subjects, of which he, at one time or another, owned eight, and of which five (two of 1842 and three of 1843) were included in

[1] *Praeterita*, Vol. II, Chap. I, para. 13; *Works*, XXXV, p. 256.
[2] *Praeterita*, Vol. II, Chap. I, para. 15; *Works*, XXXV, p. 258.
[3] *Letters to a College Friend*, No. V, para. 6; *Works*, I, pp. 428–9.
[4] *Works*, XIII, pp. 475–85.

the exhibition. This *Epilogue* was written at Brantwood, immediately after Ruskin's first attack of insanity, and dated 10th May 1878, 'Being my father's birthday, — who — though as aforesaid, he sometimes would not give me this, or that, — yet gave me not only all these drawings, but Brantwood — and all else.'[1] These words were probably added to make amends for earlier insinuations of his father's lack of generosity and meanness.

Having first approached Mr. Windus for commissions for the 1842 drawings, without success, Griffith next went with the sketches and samples to Ruskin; but his father was 'travelling for orders', and he himself 'had no authority to do anything. The Splügen Pass,' he continues, 'I saw in an instant to be the noblest Alpine drawing Turner had ever till then made; and the red Rigi, such a piece of colour as had never come *my* way before. I wrote to my father, saying I would fain have that Splügen Pass, if he were home in time to see it, and give me leave. Of more than one drawing I had no hope, for my father knew the worth of eighty guineas; we had never before paid more than from fifty to seventy, and my father said it was "all Mr. Griffith's fault they had got up to eighty".'[2] Before the elder Ruskin's return the *Splügen* was bought by Mr. Munro of Novar; but it was presented to Ruskin by a group of friends and admirers (who paid 1,000 guineas for it) during the course of the exhibition in 1878.[3]

Ruskin became, in fact, the first owner of three of the original ten 'Sunset' drawings. When his father returned he allowed Ruskin one of the drawings, and the *Coblentz* was chosen. 'By hard coaxing, and petitioning,' Ruskin also obtained his 'father's leave to promise to take a Lucerne Town, if it turned out well!' It did, and Ruskin was permitted to take it, though his father's comment was, 'I was sure you would be saddled with that drawing.'[4] Soon afterwards Ruskin bought from Griffith the *Constance*, which the dealer had himself commissioned, and concerning which Ruskin recalled in the *Epilogue*, 'the day I brought that drawing home to Denmark Hill was one of the happiest in my life'.[5] In the early 1870s Ruskin sold the *Lucerne* to the dealer Vokins for a thousand pounds: 'I wished to get *dead* Turner, for one drawing, his own original price for the whole ten, and thus did.'[4]

[1] *loc. cit.*, p. 485. [2] *loc. cit.*, p. 480. [3] *loc. cit.*, p. 487.

[4] *loc. cit.*, p. 482. Five of the 1842 and two of the 1843 drawings were included in the *Loan Exhibition of Paintings and Watercolours by J. M. W. Turner, R.A.*, shown by Messrs. Thos. Agnew & Sons in November 1967. Three of the former (Nos. 86, 89 and 90) and both the latter (Nos. 91 and 92) were at one time in Ruskin's possession.

[5] *loc. cit.*, p. 483.

RUSKIN AS A COLLECTOR OF TURNER DRAWINGS

In October 1842 the Ruskin family had moved from Herne Hill to a larger and grander house at Denmark Hill. Much later, in Chapter VIII of Vol. II of *Praeterita*, Ruskin described this as it had been in 1845. 'The breakfast-room,' he wrote, 'opening on the lawn and farther field, was extremely pretty when its walls were mostly covered with lakes by Turner and doves by Hunt.'[1] In a footnote he enumerated the former as follows : 'Namely, Derwentwater; Lake Lucerne, with the Righi, at sunset; the Bay of Uri, with the Rothstock, from above Brunnen; Lucerne itself, seen from the lake; the upper reach of the lake, seen from Lucerne; and the opening of the Lake of Constance, from Constance. Goldau, St. Gothard, Schaffhausen, Coblentz, and Llanthony, raised the total of matchless Turner drawings in this room to eleven.'[2]

The dining and drawing rooms 'had decoration enough in our Northcote portraits, Turner's Slave-ship, and, in later years, his Rialto, with our John Lewis, two Copley Fieldings, and every now and then a new Turner drawing'.[1] *The Slave Ship* (now at the Museum of Fine Arts, Boston) had been shown at the Royal Academy in 1840 (No. 203), and was purchased from Turner as a present for his son by Ruskin's father in 1844. The 'Rialto' (*The Grand Canal, Venice: Shylock*, now in the Henry E. Huntington Library and Art Gallery, San Marino) had been exhibited at the R.A. in 1837 (No. 31), and was traditionally supposed to have been painted for Mr. Ruskin, Senior. In that case it would have been the first or second work of Turner to be owned by the Ruskins, but there is nowhere any reference to it as such, and the passage from *Praeterita* quoted above must lead one to the conclusion that it did not enter the Ruskin Collection until after 1845. Both these oil paintings were sold by Ruskin in 1872.

It would seem that in the later 1840s it was not all that frequently that a 'new Turner drawing' was brought to Denmark Hill, and this was probably due to the reluctance of Ruskin's father to invest too much money in the work of one artist. This situation must have been most frustrating for Ruskin, and when he received news of Turner's death on 19th December 1851, his reaction, not altogether surprisingly, was largely to see this event as providing a golden opportunity for greatly increasing his Turner collection. Ruskin was in Venice at the time, and wrote to his father on 28th December : 'I received your letter some hours ago, telling me of the death of my earthly Master. I was quite prepared for it, and perhaps more relieved than distressed by it —

[1] *Works*, XXXV, p. 380.
[2] For further details concerning these drawings see Index I in Vol. XIII of the *Works*, pp. 597–606.

though saddened. It will not affect my health, nor alter my arrangements. The sorrow which did me harm was past when I first saw that his mind had entirely failed; but I hope I shall have another letter from you soon, for I cannot tell by this whether it has yet been ascertained that his portfolio is safe or whether — of which I lived in continual dread — he has destroyed anything. I shall not enter into any particulars about pictures to-night — being Sunday — but merely sit down to acknowledge your letter.'[1]

On the following day Ruskin wrote to his father at much length : 'Touching pictures — the first and most important of all are the original sketches of my St. Gothard and Goldau; and, if possible, the original sketches of all the Swiss drawings we have — Mr. Griffith knows which they are — but especially — after the St. Gothard and Goldau — the one of your Schwytz. You speak of sketches in *body colour*, but I never named any in my list. These sketches are in such *pure* thin water-colour that you may crumple them like bank-notes, without harm. There are, I know, unless he has destroyed them, a vast quantity, for which the *public* won't care a farthing. It is just possible that for five or six hundred pounds you might secure the whole mass of them — getting them for from three to four guineas each, or even less. I don't mean all his sketches, but *all his Swiss sketches since 1841*, and if you can do this, I should like my whole remainder, £600, spent in this way, *if necessary*. But if you find that these sketches fetch a price, and you cannot get them *all*, then spend £300 in them — doing the best you can with that sum, but securing, at all events, St. Gothard, Goldau, and Schwytz, and, if they can be found, the parcel which was first shown us in 1841, containing a Lausanne, something in that way [a rough sketch], in purple and blue sunset — very misty, and a bright coloured group of Swiss cottages. I hope Mr. Griffith may recollect the parcel — if not, you must choose those you think best out of the lot. But spend £300 in them, for this reason : I can get *more* of Turner at a cheaper rate thus, than any other way. I understand the meaning of these sketches, and I can work them up into pictures in my head, and reason out a great deal of the man from them which I cannot from the drawings. Besides, no one else will value them, and I should like to show what they are.'[2]

Ruskin had much further advice to give his father : 'Invest in *mountain* drawings of any sort you like best yourself, as I cannot give you any specific directions further than these :—

'Please do not buy for *me* any very highly laboured or popular drawing, especially if large; the popular drawings are *nearly* always bad, though our

[1] *Works*, XIII, p. xxii. [2] *Works*, XIII, p. xxiii.

Coblentz and Llanthony, for instance, are both first-rates — especially the first, and would be popular also; but, in general, a drawing much run after will be bad. . . . But the chief thing is to get mountains. A mountain drawing is always, to me, worth just three times one of any other subject, and I have not enough, yet: . . . So now I must leave you to do the best you can for me, remembering that I would always rather have *two* slight or worn drawings than one highly finished one. The thought is the thing. Buy *mountains*, and buy *cheap*, and you cannot do wrong. I am just as glad I am not in England. I should be coveting too much — and too much excited — and get ill. I must now go to my work, and keep my thoughts away from these things.'[1]

On the 31st of December Ruskin was still writing to his father about the purchase of Turners: 'I can give you one test in case any drawings should come before you — quite infallible. Whenever the colours are vivid — and laid on in many patches of sharp *blotty* colour — not rubbed — you may be sure the drawing is valuable. For Turner never left his colours fresh in this way unless he was satisfied; and when *he* was satisfied, *I* am.'[2]

But very soon Ruskin learned the contents of Turner's will, and had been informed that he was an executor (a task which he declined when the will was disputed). His reaction was to feel 'at first a little pained at all the sketches being thus for ever out of my reach; yet I am so thoroughly satisfied and thankful for the general tenor of the will that I can well put up with my own loss. Indeed I shall gain as much as I lose — in the power of always seeing all his works in London, free of private drawing-rooms. If the rest of the executors would only make me curator of the gallery I should be perfectly happy.'[3]

Ruskin immediately made plans for realising the terms of Turner's will, discounting the idea that it would be disputed by the artist's distant relatives, which it soon was, and with success. His optimism was boundless: 'I hope and believe', he wrote to his father on New Year's Day, 1852, 'that the National Gallery people *won't* build a new wing, but will leave us to do it; and that it will be a year or two before it is begun, and that then I shall have the management of it — (this between you and me) — for I would build such a gallery as should set an example for all future picture galleries. I have had it in my mind for years. I would build it in the form of a labyrinth, all on ground storey, but with ventilation between floor and ground; in form of labyrinth, that in a small space I might have the gallery as long as I chose — lighted from above — opening into larger rooms like beads upon a chain, in which the larger pictures should be seen at their right distance, but *all on the line*, never

[1] *Works*, XIII, pp. xxiv–v. [2] *Works*, XIII, p. xxv. [3] *Works*, XIII, p. xxvii.

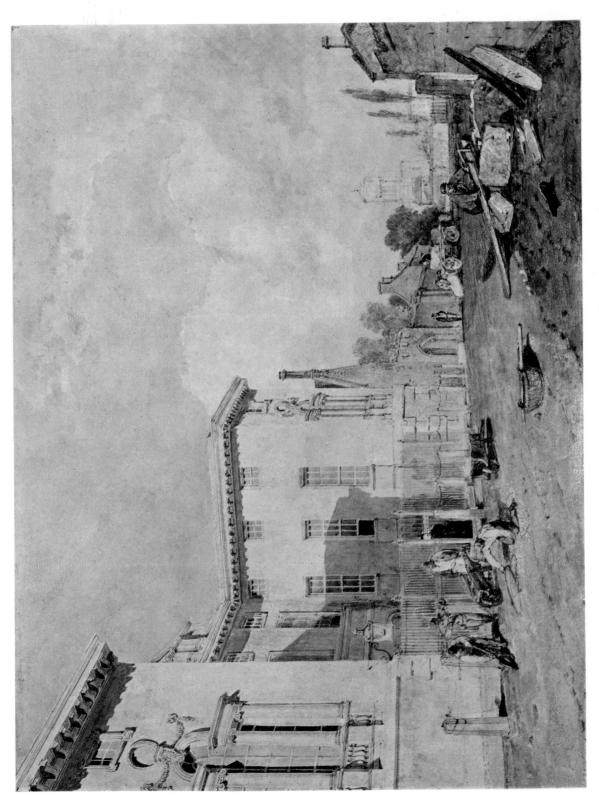

A. 4. 'A View of Worcester College &c.'. (320 : 443 mm.)

one picture above another. Each picture with its light properly disposed for it alone — in its little recess or chamber. Each drawing with its own golden case and closing doors — with guardians in every room to see that these were always closed when no one was looking at *that* picture. In the middle of the room — glass cases with the sketches, if any, for the drawing or picture, and proofs of all engravings of it. Thus the mass of diffused interest would be so great that there would never be a crowd anywhere : no people jostling each other to see two pictures hung close together. Room for everybody to see everything.'[1]

The elder Ruskin was clearly relieved at the turn of events, though his son still continued to bombard him from Venice with advice about the purchase of Turner drawings. Despite the terms of the will, Ruskin must still have thought that Turner's death would bring a quantity of his work onto the market. On 23rd January, in a letter which included a list of drawings divided into four classes of desirability, he wrote : 'I should certainly hope now and then to be able to buy a Turner, for some years to come, if I do not succeed in getting them at the sale — for they are to me Nature and art in one — all that I best love in nature with all that I most revere in art. I am *content* with my collection *now*, as I said, but the exquisite pleasure that every new one gives me is like a year added to my life, and a permanent extension of the sphere of life.'[2] But the father was not really moved by this or any other appeal. About a month later, in a letter describing a visit 'through Turner's house with Griffith' he wrote : 'It seems to me you may keep your money, and revel for ever and for nothing among Turner's Works.'[3]

At the end of February Ruskin sent his father yet another appeal for the purchase of more Turners : 'I stopped to-day just as I was coming to that part of your letter when you say we shall — or should have too much (£10,000) in Turner, because I should not see my pictures if I went to the Alps. But do you count for nothing the times out of time you see me looking at them morning and evening, and when I take them up to sleep with ? I have fifty pounds' worth of pleasure out of every picture in my possession *every week* that I have it. As long as you live, I shall not be so much abroad as in England; — if I should out-live you, the pictures will be with me wherever I am. . . . Either I know this man Turner to be *the* man of this generation — or I know *nothing*. You cannot wonder that, as long as I have any confidence or hope in myself, I should endeavour to possess myself of what at once gives me so great pleasure, and ministers to what I believe to be my whole mission and duty here. It is a

[1] *Works*, XIII, pp. xxviii–ix. [2] *Works*, XIII, p. xlviii. [3] *Works*, XIII, p. xxvii.

25

pity that I cannot frankly express my feelings on this subject without giving you cause to dread the effects of enthusiasm; but it is just because I am enthusiastic that I am — *if* I am — powerful in any way. If you have any faith in my genius, you ought to have it in my judgment also. You may say (probably all prudent fathers *would* say), "If he wants to buy all these just now, what will he want to buy as he grows older? — He began with one — and thought himself rich with two — now he has got thirty, and wants thirty more : in ten years he will want three hundred." I feel the force of this reasoning as much as you do, . . . But I can very firmly and honestly assure you that I *am much* more satisfied with my collection now than when it was smaller, and that if I now express more exorbitant desires, it is not because I want more, but because you are more indulgent to me. When I was a mere boy, I had not the impudence to ask you — or even to hope for — a present of more than £50 once a year. Then it came to £160 once a year, and my *expression* of desire has always increased exactly in proportion to the degree in which I thought it might be expressed without giving you pain. The longings were always there, but I did not choose to utter them — knowing that they would cause you suffering — perhaps also knowing that their expression would be of no use, — they would not be granted. Yet you may remember that when Griffith proposed to sell his whole collection, I did in a humble manner lay his offer before you — of fifteen drawings at £50 each. You gave me four, and I did not press the rest; but be assured, I longed for them just as much as I do now — though I did not then know half their value, else I should have permitted myself in more importunity. Again, when the offer of twenty drawings at £40 each was made to us, I laid it before you, in a timid hope that you might take them. I had exactly, myself, as much longing and as large desires as I have now — nay, greater, by the smallness of my possessions — but I had not the face to express them. Now that I am older and wiser, and you are more indulgent, I come out with all that I want, and it looks as if my desires had greatly increased, but they have not increased one whit. I am, on the contrary, infinitely nearer contentment than I was, and if I had the drawings named in my first and second class, and a bundle or two of sketches, I certainly should never feel sickness of heart for a Turner drawing any more. As it is, I think that my going on quietly with my work here, while such things are going on in London, may show you that I am *tolerably* content with what I *have* — though, in sober conscience, I think it right and wise to "ask for more".[1]

When Rosie (Rose La Touche) paid her first visit to Denmark Hill in the

[1] *Works*, XXXVI, pp. 134–5.

autumn of 1858 there were thirty Turners for her to see.[1] It would seem that Ruskin's plea for more Turners must have met with little success, though there were probably also quite a number of drawings not on the walls. The mid-1850s were very busy years for him, and saw the publication of Volumes II and III of *The Stones of Venice* in 1853 and, three years later, of Volumes III and IV of *Modern Painters*, as well as various other writings. These included the 'Illustrative Text' to the series of engravings after Turner published in 1856 with the title *The Harbours of England*. In 1857 and 1858 Ruskin was hard at work in arranging the vast quantity of drawings in the Turner Bequest. Turner's will had indeed been disputed and, while by the settlement ultimately arrived at the next-of-kin received the greater part of the estate, 'all the pictures, drawings, and sketches by the testator's hand, without any distinction of finished or unfinished, are to be deemed as well given for the benefit of the public.'

Although Ruskin had declined to act as an executor, when the contents of Turner's studio and gallery were at length handed over to the National Gallery in the autumn of 1856, he hurried back to England and offered to undertake the arrangement of the drawings. He first offered to do this in a remarkable letter to *The Times*,[2] which he followed a few weeks later with a private letter to the Prime Minister, Lord Palmerston, whom he knew. In this letter[3] he wrote: 'Finally, as the simplest test of my fitness for the task, I may perhaps be permitted to refer to the preservation and arrangement of my own collection, now the third in importance among the private Turner collections of England.'

Ruskin finally received the authority he needed to examine, sort, select from and arrange the immense quantity of drawings, some nineteen to twenty thousand items in all. It was a difficult and often frustrating task, at which he worked with immense energy in the winter of 1857–8. In his *Preface* to the fifth volume of *Modern Painters*, published in 1860, Ruskin wrote an account of this undertaking, on which he was 'at work . . . every day, all day long, and often far into the night. The manual labour', he continued, 'would not have hurt me; but the excitement involved in seeing unfolded the whole career of Turner's mind during his life, joined with much sorrow at the state in which nearly all his most precious work had been left, and with great anxiety, and heavy sense of responsibility besides, were very trying; and I have never in

[1] *Praeterita*, Vol. III, Chap. III, para. 54; *Works*, XXXV, p. 527.
[2] 28th October 1856; *Works*, XIII, pp. 81–5.
[3] *Works*, XIII, pp. 85–6.

my life felt so much exhausted as when I locked the last box, and gave the keys to Mr. Wornum, in May, 1858.'[1]

Ruskin's own collecting of Turner was not, however, entirely neglected during this period of great activity. His Diary for 11th February 1858 reads, 'Grey. Day of getting the *Loire*.'[2] This cryptic entry refers to the acquisition of the majority of the series of beautiful drawings for *The Rivers of France*, which formed the nucleus of Ruskin's gift to Oxford in 1861 (Nos. 29–51 in the *Catalogue* below). It was only the seventeen published drawings which Ruskin purchased on that day for 1,000 guineas (see below, p. 34). The seller was Mrs. Cooper, wife of the Rev. James Cooper, who was Third Master at St. Paul's School from 1824 until his retirement in 1861. Their son, Canon Cooper, informed Cook and Wedderburn that his mother sold these drawings to purchase a commission in the army for another son.[3] Unfortunately it has proved impossible to discover the maiden name of Mrs. Cooper, which might have provided a clue as to how she had come into the possession of these and other Turner drawings.

Ruskin had long coveted these drawings; he is reported to have told Mr. George Allen, his publisher: 'One day Turner came to me with a bundle in a dirty piece of brown paper under his arm. It contained the whole of his drawings for the *Rivers of France*. "You shall have the whole series, John," said he, "unbroken, for twenty-five guineas apiece." And my father actually thought I was mad to want them!'[4]

In 1871, in his third course as Slade Professor at Oxford, the *Lectures on Landscape*, Ruskin spoke as follows of his gift of these drawings: 'I do not doubt that it has often been matter of wonder among many of you who had faith in my judgement, why I gave to the University, as characteristic of Turner's work, the simple and at first unattractive drawings of the Loire series. My first and principal reason was that they enforced beyond all resistance, on any student who might attempt to copy them, this method of laying portions of distinct hue side by side. Some of the touches, indeed, when the tint has been mixed with much water, have been laid in little drops or ponds, so that the pigment might crystallize hard at the edge. And one of the chief

[1] *Works*, VII, p. 5.

[2] *Diaries*, II, p. 534.

[3] *Works*, XIII, p. 462, n. 4. I am most grateful to Mr. A. N. G. Richards, Archivist of St. Paul's School, for generously providing all the available information concerning the Rev. James Cooper.

[4] *Works*, XIII, p. li.

delights which any one who really enjoys painting finds in that art as distinct from sculpture is in this exquisite inlaying or joiner's work of it, the fitting of edge to edge with a manual skill precisely correspondent to the close application of crowded notes without the least slur, in fine harp or piano playing.'[1] And slightly later in the same lecture he returned to the series: 'Well, the first reason that I gave you these Loire drawings was this of their infallible decision; the second was their extreme modesty in colour. They are, beyond all other works that I know existing, dependent for their effect on low, subdued tones; their favourite choice in time of day being either dawn or twilight, and even their brightest sunsets produced chiefly out of grey paper.'[2]

Ruskin was, in fact, under a misapprehension in thinking that the paper of these drawings was originally grey. Both in the examples which he gave to Oxford, and in the far larger number of *Rivers of France* drawings forming part of the Turner Bequest, the paper was originally blue. All those at Oxford have more or less faded to grey, as have many of those in the Turner Bequest which have at any time been exhibited. It requires only a brief period of regular exposure to light for such fading to take place, and Ruskin's Loire drawings must already have been faded when he purchased them in 1858.

Ruskin was fully aware of the danger of exposing water-colours to light, and entered into several controversies about the hanging of drawings. The frames of those of his own Turners which were hanging were fitted with dark green calico covers. His other examples were kept in closed cabinets similar to those he introduced in the National Gallery, and later at Oxford and Cambridge. In these each drawing was mounted and framed under glass in a simple moulding, which slid easily into and out of a solidly constructed mahogany cabinet designed to hold some twenty-six such frames.

Fifteen years after his gift of the Loire drawings Ruskin wrote in Letter 62 of *Fors Clavigara* (February 1876): 'When I gave away my Loire series of Turner drawings to Oxford, I thought I was rational enough to enjoy them as much in the University gallery as in my own study. But not at all! I find I can't bear to look at them in the gallery, because they are "mine" no more.'[3] It is, indeed, somewhat surprising that he should have parted with these precious drawings so soon after acquiring them, and, furthermore, it seems possible that the idea of his gift to Oxford was already in his mind within two and a half months of their purchase.

In the catalogue entry for another of the drawings given in 1861, '*Jericho*'

[1] *Works*, XXII, pp. 51–2. [2] *Works*, XXII, pp. 55–6.
[3] *Works*, XXVIII, p. 519.

(No. 55), reference is made to the brief ownership of this water-colour by the artist J. F. Lewis. The first of the five letters from Ruskin to Lewis which accompanied the copy of 'Jericho', seen at the British Museum in 1948, is dated 10th April 1858. In it Ruskin wrote: 'I've got Jericho for you. The Turner drawing you said, I think — you liked — and if you still like it and will give me two sketched for it: it is yours.'[1] The exchange took place, for in the second (undated) letter Ruskin wrote: 'I will never part with the sketches — nor publish them — & if you tire of the Turner — you must not part with them but to me, at least without giving me warning.' He emphasised this in the third letter (dated 11th April): 'Touching the Turner, certainly I meant it — they must go to no one but me — The money shall be always ready for them. I would not have parted with them at all but to you — and shall be most glad to have them again —.'

Lewis, whom Ruskin later described in *Praeterita* as 'the painter of greatest power, next to Turner, in the English school',[2] was clearly not entirely happy with his Turner drawings, and on 28th April Ruskin wrote yet again about taking them back: '. . . if there is any one you would like to offer those Turners to, I will waive my claim upon them — or if Vokins [the dealer] likes to give you a larger price for them — you had better so arrange it — the 180 guineas are at your disposal — whenever you like — only I have just heard of a need which may make it necessary for me to part with them in the course of the year even if I took them now. . . .'

It may be presumed that this 'need' was the gift to Oxford, in which the 'Jericho' was ultimately included. However, it took nearly three years more before Ruskin made his gift of Turner drawings in March 1861, and in those three years he clearly added considerably to his collection. The list of *Turner's Drawings in the Collection of J. Ruskin, Esq.*, printed in the Appendix of Walter Thornbury's *Life of J. M. W. Turner, R.A.*,[3] published in 1862, includes most of the drawings given to Oxford and Cambridge, and must, therefore, have been drawn up early in 1861 at the latest. This list names eighty-one drawings specifically; in addition the two final items are *Sketches of Venice*, and *Early Sketches (various)*. Thus Ruskin's gift of forty-eight drawings to Oxford

[1] Typed copies of these letters, from which this and the following quotations have been taken, were most generously sent to the Ashmolean Museum at the time by Mr. Edward Croft-Murray, who saw the oil copies of 'Jericho' and of the 'Pools of Solomon' in March 1948 (see below, p. 82).

[2] *Praeterita*, Vol. II, Chap. IX, para. 173; *Works*, XXXV, p. 403.

[3] Vol. II, pp. 395–6.

and twenty-five to Cambridge some two months later, was indeed outstandingly generous.

The detailed story of the Oxford gift can best be traced in three letters from Ruskin to his great friend Dr. Henry Acland, of which the two earlier are here published for the first time. This correspondence opens with Ruskin's letter of 7th March 1861, written at Denmark Hill: 'My dear Acland. What kind of Keepership — of warming; of fire-guarding — has the Taylor gallery. Ive done my work about Turner as far as help was needed for it from drawings in my possession and I don't care to keep 1500 pounds worth of him in my table drawers, while I go abroad — or work at political matters. I could give the Loire series of the Rivers of France and ten or twelve other small drawings — with some unique early sketches and such things to Oxford, if I could be sure they would be properly taken care of: will you please report to me on this matter. I intended once to have given them to the National Gallery, but, I believe now that there's art examination &c and your museum at Oxford, they will be more useful there. . . . P.S. What are you doing with my wave? I shall want it back soon now.'[1]

The second letter, which is neither dated nor bears an address, reads: 'Dear Acland. Best thanks for your letter — but it is of no use for me to come down. for you can't have a teacher at Oxford just now. It is all nonsense to think about it. Nobody among our painters knows what painting means. except old William Hunt and a mad *PRB* or two. the professor and lecturers know neither what painting means nor what it was meant for — There is literally not a human being who can tell you anything but lies; I mean available for

[1] This (MS. Acland, d. 73; fols. 246–7) and the following letter (fols. 234–5) are among the Acland Manuscripts in the Bodleian Library, and are published here by permission of Messrs. George Allen and Unwin. I am most grateful to Dr. H. C. Harley for having drawn my attention to the volume of Ruskin's letters in the Acland papers.

Dr. (later Sir) Henry Acland (1815–1900) was an undergraduate at Christ Church with Ruskin, and they became life-long friends. Acland was Regius Professor of Medicine at Oxford from 1858 to 1894, and was largely responsible for the building of the University Museum, of which the foundation stone was laid on 20th June 1855. Ruskin took an active part in this project.

'My wave' in the post-script of the first letter refers to a drawing by Ruskin; the two men had exchanged drawings of waves.

The 'William Kingsley of Cambridge' mentioned in Ruskin's second letter probably refers to the Rev. William Kingsley, Fellow and Tutor of Sidney Sussex College, and later Rector of South Kilverton, Thirsk. Mr. Kingsley gave Ruskin a number of Turner drawings (Nos. 72–4 below), and wrote the *Notes* which were first printed in the Seventh Edition of the catalogue of the 1878 Exhibition; *Works*, XIII, pp. 533–6.

pay. If you could have got William Kingsley of Cambridge he would have done for a full Art Professor-ship — but he's ill (something wrong with his brains Im afraid — sees and hears things that Are'nt.) So all you can do is to take the Turners and keep 'em safe — and don't jump upon *them* (if there's a fire) instead of *on* the fire.

'I've looked over what I'm going to send. and find I've paid 2100, odd pounds for them — some are now worth more — some perhaps less — as these among the *best*, I've let myself be cheated in order to get hold of them — the market value is as near 2000 as possible: this being so the gallery must pay for cases for them. and have them like those I got for the National Gallery (will cost £100 perhaps more or less — I would do it but have no money handy. If there's any serious difficulty about it — for I don't believe anybody will ever think the drawings worth the case — I'll do it myself). I hope to send my man down with them on Monday. as I want them out of my way now — at least if you can put them in a safe place. Say Tuesday and I will have them nicely ready with a list. I shall add a little one — a vignette which I should like you to keep yourself in memory of wave and wreck.

'I can't be bored by talking to people. I'm going to study the crystallization of hornblende with Maskelyne — and the world may take care of its own business for me at present.'[1]

As the last paragraph indicates Ruskin was undergoing a period of great depression at this time. The next letter,[2] again undated, is carelessly and erratically written, but provides a valuable insight into Ruskin's opinions about the drawings he was giving away. Where they are relevant to the drawings, quotations from this letter are also given in the individual *Catalogue* entries.

'Dear Acland. I have the wave safe — it is very beautiful. It seems to me bettered in the near part — less tiny.

'I'm so glad you like to have the Turner. I fancied you would like the Acropolis one — for old times' sake at Athens. It is also the best vignette I

[1] See note 1 on the preceding page.

[2] The original of this letter, excluding the second part of the post-script, was presented to the Ashmolean Museum by H. D. Acland in 1932 (part of No. 129 in the *List of Drawings and Engravings in Albums, Boxes, etc.*, Ashmolean Museum, 1962). The whole letter was printed on pp. 358–9 of Vol. XXXVI of the *Works*.

The numbers used by Ruskin in this letter refer to those in the list in his own hand, dated 12th March 1861, which is preserved in the archives of the Department of Western Art. This is referred to in the *Catalogue* entries as 'the original list of Ruskin's 1861 gift'. Nos. 51 and 52 in that list were both engravings. See also the concordance given below on p. 64.

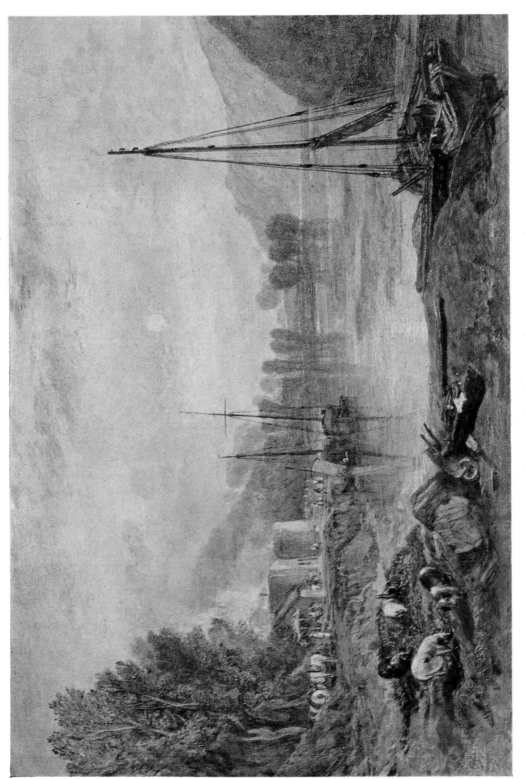

B. 76. Sunshine on the Tamar. (217 : 367 mm.)

have : though not as fine in colour as Turner usually is : very full of marvellous drawing as you will see.

'I *have* two still — Ashestiel and Linlithgow — kept for love of Scott : and for my father who likes Linlithgow — but both are bad ones. I have still seven or eight first rate body colours, small — which will serve all my purposes of reference when I am myself at work.

'Of those sent to Oxford the numbers 1, 2, 6, 7, 8, 12, 18, 19, 21, 22, 24, 26, 27, 28, 29 are entirely first-raters. The 12 is as peculiar as it is masterly — but its price is of course absurd. I wanted it a long time and at last got it from its possessor (Mrs. Cooper, wife of master at St. Paul's) for 50 g. — on the condition that she might claim it again for the same sum, when she chose. I didn't like the condition and offered her the sketch No. 9 — for which I had given 40 g., if she would give up her Meuse finally — She accepting; tired of the Yarmouth, which I ransomed for 30 — the two drawings thus finally costing me the one 80 — the other 40 — but I've marked the Meuse only 70, as there was ten guineas' worth of mere gift in the matter.

'No. 17, though containing hardly half-an-hour's work is so first rate that I would have given *anything* for it — I *gave* 50, but of course in the market it would bring only 30 or 35. On the contrary Nos. 1 and 2 would I believe each fetch from 100 to 120, and 3 and 4 at least 100 each. No. 21, the best of the Loire series, is priceless, and 24 nearly so. 28 and 29 entirely magnificent in their own quiet way. 35 is inferior owing to a repentir [*pentimento*] in the left corner — Turner never recovered after a repentir. 25 has two repentirs if not more — one in the sun : the other in the flags — but has high qualities here and there — 30 and 36 are full of repentirs and are entirely bad; but I sent them with the rest — lest it should be thought I had kept the two best — many people might think them so — They are instructive as showing the ruin that comes on the greatest men when they change their minds wantonly.

'Let me hear you are better. — Ever affectionately yours, J.R.

'P.S. The frames into which the drawings are to be put by the people I've sent down are only temporary : being those they were in here. For public use they must have much stronger and better ones — Williams will tell you about the National Gallery cases and give you all the information necessary for determining the arrangement.

'Yes, if the Oxford people would put up with a thistly teacher — it is possible to get one useful enough.

'Prices paid by me, for the drawings sent to Taylor Gallery, March 12th, 1861 :

No. of Drawing	Price in Guineas	No. of Drawing	Price in Guineas
1	90	14	50
2	90	15	40
3	80	16	40
4	80	17	50
5	70	18	40
6	55	19	40
7	55	20–36	1000
8	55	37–50	100
9	40	51	15
10	50	52	20
11	50		
12	70		2220 g.
13	40		£2321'

These three letters, and especially the last, reveal Ruskin's somewhat mercenary attitude towards his collecting activities — an attitude which was no doubt the result of his father's influence. We do not know how the latter reacted to his son's giving away over two thousand pounds' worth of Turners. Though now less active, he lived until 1864, but his influence over Ruskin waned considerably after 1858.

Ruskin wrote the list accompanying his gift in his own hand, and headed it *List of Turner drawings sent for Taylor gallery. March 12, 1861'* (see p. 64). Some two weeks later he received the following official letter from the University : 'We the Chancellor, Masters and Scholars of the University of Oxford, beg to offer you our grateful acknowledgements for your valuable and very seasonable present.

'A Collection of Pictures of such intrinsic value must at all times be a most acceptable acquisition. But at this particular season the donation is most welcome, as calculated in our estimation to stimulate the cultivation of a class of studies to which the University has of late been disposed to extend a more than usual measure of encouragement. Of the additional value thus attaching to your donation we assure you that we are by no means insensible; and at the same time we would express the still higher sense of gratification which we feel, when we call to mind the distinguished position which its donor has won for himself amongst the patrons of the art so beautifully illustrated in this collection.

'Given at our House of Convocation under the Common Seal this twenty-third day of March in the year of our Lord God, 1861.'[1]

Ruskin was clearly satisfied with the way in which his gift was received. The drawings were ultimately placed in 'two costly cabinets', also provided by Ruskin (despite his earlier reluctance to pay for them), and housed in the 'Ante Room' of the University Galleries (as the Ashmolean Museum was then called), in which the ten Turner Oxford Almanack drawings were hung on the walls. On 10th May he wrote to the Vice-Chancellor of the University of Cambridge: 'Finding that a small series of sketches & drawings by J. M. W. Turner, which I arranged lately for my own University, was thought likely to be useful there, I have now got into order a series of the same kind, though somewhat less extensive, which I thought might be perhaps accepted at Cambridge, for the Fitzwilliam Museum. It consists of twenty-five drawings & sketches, which I have chosen, as well as I could, out of my remaining collection, to illustrate Turner's modes of work at various periods of his life. They are all small, and the market value will not at present be more than 1400 pounds; but I think they may be useful for reference and occasional example to the younger students who may take interest in the study of English art & in the practice of drawing.'[2] The drawings were forwarded to Cambridge on 28th May, which is the date on the printed *Catalogue of Drawings by J. M. W. Turner, presented to the Fitzwilliam Museum by John Ruskin*. In June Ruskin went to Boulogne for a seven-week rest.

The group of twenty-five drawings given to Cambridge includes the *Ashestiel* mentioned in the third letter to Dr. Acland (p. 33 above). There are also four unpublished drawings from the *Rivers of France* series, several outstanding examples of the later Swiss water-colours, and three superb Venetian studies. Ruskin included all the Venetian sketches he ever owned in his gifts to Oxford and Cambridge: it has been suggested by A. J. Finberg that this was because of his dismay at the 'modernising' developments in Venice at this time.

'Resolve to have some more Turners and if I live, some of my own way at last'; thus wrote Ruskin in his Diary, when in Geneva, on 7th August 1862.[3] From 1860 onwards an ever-increasing number of drawings by Turner appeared in the London sale-rooms, and Ruskin must have been a frequent

[1] Official copy in Bodleian Library; MS. Top. Oxon. b. 103, fol. 28.

[2] This letter is preserved in the Fitzwilliam Museum, Cambridge, and is quoted here by permission of the Syndics.

[3] *Diaries*, Vol. II, p. 566.

buyer; in his Diary, however, there are only a very few references to the purchase of drawings. But, on 30th March 1868, he wrote: 'Last week taken up with buying Turners at auction, etc.'[1] A search through the relevant auction catalogues of that month has not, however, produced evidence of any drawings purchased by Ruskin, and it must be presumed that most of his acquisitions were made through dealers (such as Gambart, Vokins and Wallis), and privately.

In 1869 Ruskin acquired some additional Turners through the dispersal of the John Dillon Collection, at Christie's on 19th April and at Sotheby's between 16th and 19th June. Just before the first of these two sales Ruskin himself sold forty drawings by Turner in a sale at Christie's on 15th April. These realised some 2,200 guineas.

In August 1869 Ruskin was appointed the first Slade Professor of Fine Art at Oxford. He gave his inaugural lecture the following year, on 8th February, his fifty-first birthday. The appointment affected Ruskin's collection in two very different ways. In 1871 he was elected to an Honorary Fellowship at Corpus Christi, where he was allotted rooms in the Fellows' Buildings. To these rooms, which looked out on to the meadows, he brought 'a large portion of his choicest manuscripts, engravings, books, drawings, and pictures. To Oxford also he brought a portion of his beautiful collection of minerals, contained in two of the five cabinets which his father had given him, when a youth beginning to study. Ruskin, when at Oxford, would show his treasures to pupils, friends, or distinguished visitors, with comments, explanations, rhapsodies, as formerly at Denmark Hill.'[2] In 1872 the contents of his rooms at Corpus were insured for £30,000.

From the moment of his appointment at Oxford Ruskin began to formulate the plans which led ultimately to the foundation of the Ruskin School of Drawing and Fine Art, though the final Deed for this was not signed until 31st May 1875. Ruskin's aim, as outlined in a letter written to Dr. Acland on 14th March 1871, was the 'establishment of a system of art-study' in the University Galleries, which would enable 'the grammar of all the arts' to be 'taught to young persons residing in Oxford or its neighbourhood'.[3]

The University agreed in principle, but the transaction was far from complete when Ruskin fell seriously ill at Matlock in the summer of 1871. When Dr. Acland visited him, Ruskin handed him a cheque for £5,000 to endow the Mastership. In the following months Ruskin was hard at work in assembling, arranging and cataloguing the various 'Series of Examples' — drawings and

[1] *Diaries,* Vol. II, p. 646. [2] *Works,* XX, p. xxxiii. [3] *Works,* XXI, pp. xix–xx.

prints by a variety of artists, as well as photographs and reproductions — which were to play an essential role in the system of instruction used at the School, the first Master of which was Alexander Macdonald. These four 'Series', which were entitled 'Standard', 'Reference', 'Educational' and 'Rudimentary', were constantly being altered. The Schedule attached to the Deed of 1875 listed twenty-seven drawings by Turner; several of these were subsequently removed while others were added, leaving, in the end, the twenty-eight drawings included as Nos. 59 to 86 in the *Catalogue* below.[1]

Thirteen of these drawings date from 1801 or earlier, three from 1809, five from 1810 to 1820, three from 1820 to 1830, and the remaining four from about 1840 or later. Thus the Turner drawings in the Ruskin Art Collection complement those presented by Ruskin in 1861 to provide an overall survey of Turner's work as a draughtsman. Though it was never actually stated, it seems probable that Ruskin made the various changes among the Turner drawings in the Ruskin Art Collection in order to achieve as complete a representation as possible. A few years later the exhibit of Turner's work in Oxford was greatly strengthened when Ruskin succeeded in persuading the Trustees of the National Gallery to sanction the loan to the University of some 250 drawings and sketches selected by him from the Turner Bequest. These remained in Oxford from 1879 until 1906.

The Ruskin Drawing School was housed (as it still is) on the ground floor of the West Wing of the University Galleries, and was ready for use by the end of 1871. It was fitted out at Ruskin's expense, and the collection was arranged in the special cabinets devised by him. He could not, however, have had a direct hand in the final arrangement, for from early October until her death on 5th December, Ruskin was confined to Denmark Hill by the dangerous illness and decline of his mother. The Ruskin Drawing School became one of the sights of Oxford, and at first Ruskin appears to have been satisfied with the arrangements. The nature and purpose of the Ruskin Art Collection are discussed at length in the *Introduction* to Volume XXI of the *Works*, and that Volume also contains the Catalogues of the various Series.

There is little evidence of Ruskin's collecting activities in the 1870s; this was a period of increasing strain and illness, and his interest in Turner declined. In letter 76 of *Fors Clavigara* (April 1877) Ruskin, as 'Master of the Guild of St. George', discussed in detail his financial position and his property.

[1] The drawings and prints in the Ruskin Art Collection are now deposited in the Print Room of the Department of Western Art at the Ashmolean Museum. This transfer was initiated in 1938 and completed when the new Print Room was opened in 1950.

The references to his collection are disappointingly uninformative: 'I parted with some of my pictures,' he wrote, 'too large for the house I proposed to live in, and bought others at treble the price, the dealers always assuring me that the public would not look at any picture which I had seen reason to part with; and that I had only my own eloquence to thank for the prices of those I wished to buy.'[1] Later in the same letter, in a valuation of his property, we read: 'pictures and books, at present lowest auction prices, worth at least double my Oxford insurance estimate of thirty thousand.'[2] In the following discussion of his future outlay, Ruskin wrote: 'New Turner drawings are indeed out of the question; but as I already have thirty large and fifty or more small ones, and some score of illuminated MSS., I may get through the declining years of my aesthetic life, it seems to me, on those terms, resignedly, and even spare a book or two — or even a Turner or two, if needed — to my St. George's schools.'[3]

On 9th June 1877, Ruskin wrote in his Diary: 'Wonderfully better in spirit, and gaining strength, and given, by St. Ursula, five new Turners: *Narni Bridge*, *Carnarvon*, *Leicester Abbey*, and a *Rouen* and *Louth*, which I don't know about, giving me gladness in going home.'[4] Ruskin was in Switzerland at this time, and these drawings had been purchased on his behalf by Arthur Severn at the great sale of Turner drawings from the collection of H. A. J. Munro of Novar, held at Christie's on 2nd June 1877. Arthur Severn (1842–1931), the youngest son of the painter Joseph Severn, had married Ruskin's cousin Joan Agnew in 1871. Two years later the Severns moved to Brantwood, the house on the eastern side of Coniston Water, which Ruskin had purchased in the late summer of 1871, and which was to be his principal home for the last twenty-eight years of his life. Most of his own Turner drawings were soon hung at Brantwood, especially in his bedroom.

On 10th June Ruskin wrote to Mrs. Severn: 'I think the getting of these new Turners will be of great importance to me. It will set me *on* Turner again, and I think I shall now give a course of lectures on him at Oxford, incorporating all I've said and would say of him, and add some sufficient account of his life, and so publish.'[5] He returned to Denmark Hill on 17th June, and wrote in his Diary: 'safe home, . . . *Leicester Abbey*, *Carnarvon* and *Narni* beside me, and the nightingales singing from three till now incessantly.'[6]

[1] *Works*, XXIX, p. 100. The house was Brantwood; the pictures sold (both in 1872), *The Slave Ship* and *Venice: the Grand Canal*.

[2] *loc. cit.*, p. 102. [3] *loc. cit.*, p. 103. [4] *Diaries*, III, pp. 959–60.

[5] *Works*, XXV, p. xix. [6] *Diaries*, III, p. 962.

Ruskin was again enjoying his Turners, but unfortunately his plan to lecture and publish on him was not to be fulfilled. On 1st January 1878 he was in Oxford, and his Diary for that year opens: 'Began the year with Turner at Eaglestone and Bolton, Oakhampton and Carnarvon, putting them out to look at, as the bells of Ch[rist] Ch[urch] and Merton rang in the year.'[1] During the following weeks Ruskin was busy preparing his *Notes* for the Exhibition of *His Drawings by the late J. M. W. Turner, R.A.*, which was to open at The Fine Art Society's Galleries, 148 New Bond Street, in March. But the following announcement had to be inserted on a slip in the first edition of these *Notes*: 'In consequence of Mr. Ruskin's sudden and dangerous illness the latter portion of these Notes is presented in an incomplete state, and the Epilogue remains unwritten. February 27th, 1878.'[2] Ruskin had finished the first draft of his catalogue on 21st February; two days later he was struck down by his first severe attack of brain fever.

The Exhibition, however, went on; and, judging by the twelve editions of the *Notes* issued during its showing, it was a great success. It included a total of 114 drawings by Turner; seventy in the main groups, the remainder '*Illustrative Studies and Supplementary Sketches*', and also three sketch-books among the '*Addenda*'. For the Exhibition three early water-colours were lent from the Ruskin Art Collection at Oxford (Nos. 59, 60 and 63 in the *Catalogue* below), and *Sunshine on the Tamar* (No. 76), which was not finally presented until 1886, was also shown.

Ruskin had asked for the loan of the three Ruskin School drawings in a letter written to Alexander Macdonald from Brantwood on 28th January 1878: 'Then, please, I shall want in about three weeks the loan of three of the School drawings! "Bergamo", the boat, and the little unfinished water colour abbey in the Turner practice cabinet. I want them to take their part — specified as belonging to the University Galleries — in my great Turner Exhibition this spring. There are two drawings also which I shall want, that don't belong to the galleries . . . but will you please speak to Dr. Acland about the other three. . . .'[3]

The *Notes* do not reveal a great deal about Ruskin as a collector, though there are occasional references as to how he acquired a particular drawing. They do show, however, that Ruskin was keenly concerned with questions of

[1] *Diaries*, III, p. 972. [2] *Works*, XIII, p. 394.

[3] A copy of this letter, made in 1901 by T. W. Jackson, is in the Ruskin School Archives. I am most grateful to the Ruskin Master, Mr. Richard Naish, and to the School's Secretary, Mrs. Joan Rhoades, for their assistance in making these Archives readily available.

technique and that he was trying to work out a reliable chronology for Turner's drawings. As soon as he had sufficiently recovered from his illness, Ruskin completed his *Notes* and wrote the *Epilogue* about the Swiss drawings of 1840 to 1845, which was first included in its complete form in the Seventh Edition of the *Notes*, issued at the end of May.[1]

On 22nd August there is an unusually long Diary entry about Ruskin's activities during July and August. This closes as follows: '. . . got home here [Brantwood], with all my Turners safe, the day before yesterday, 20th August. So I have had twenty days' work on Turners in National Gallery, and twenty days' rest in the hills, and ought now to be able for quiet routine, if I don't eat what I should not, or read vexing letters.'[2] In the National Gallery he had been making the selection for the loan of Turner drawings to Oxford. The Director of the National Gallery, F. W. Burton, had written to Ruskin on 7th August: 'The Trustees are quite content to acquiesce in the selection you have made, out of our Turner treasure, for the Oxford Schools. . . .'[3] Ruskin sent this letter to the Ruskin Master, and early in 1879 the drawings were in Oxford. In another letter to Mr. Macdonald, dated 22nd January, Ruskin wrote: 'Yes, you will find the new Turners a treasure indeed. I wish you would ask the Dean and Dr. Acland whether on the strength of this "loan" from the National Gallery they would think themselves able to lend me for a while my dear old Château de Blois — I want to finish an old drawing from it.'[3] The Turner drawing is No. 44 below, and it *was* lent to Ruskin, for one of three new plates in the 1888 edition of Volume V of *Modern Painters* was an aquatint after the drawing, etched by Ruskin and engraved by T. Lupton. There is also a later reference to the return of this Loire drawing.

Ruskin had written on 18th November 1878 to the Dean of Christ Church, Dr. Liddell, resigning the Slade Professorship, and during the following months he spent most of his time quietly at Brantwood. The artist William Blake Richmond was appointed to succeed Ruskin as Slade Professor. In July 1879 Ruskin wrote from Brantwood to Mr. Macdonald: 'when you return to Oxford, I want all sent down here that is not in the catalogue as I last wrote it'; and a few days later: 'I didn't mean certainly *all* in the standard frames — but I think it highly desirable that no more of my own drawings should be left in the school than are really necessary — and the standard frames are meant

[1] In the 'Bibliographical Note' on pp. 393–402 of Vol. XIII of the *Works* the complicated problems of the fourteen editions of the *Notes* are fully discussed.

[2] *Diaries*, III, pp. 976–7.

[3] Ruskin School Archives; copy by T. W. Jackson.

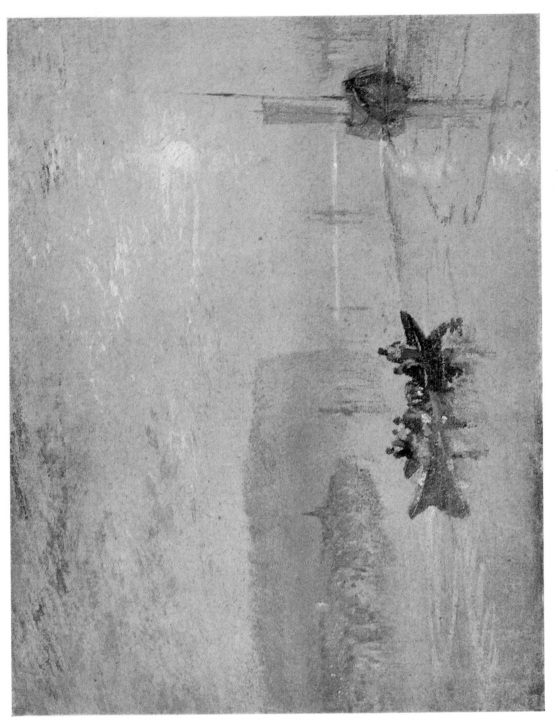

C. 50. 'Scene on the Loire' (near the Coteaux de Mauves).
(140 : 190 mm.)

for standards — not for my sketches. If you could fill them at once with Turners, and send me whatever sketches are not in *the schedule at the time of signing the gift*, I think it would be more *mannerly* on my part and expedient for all parties.'[1] Ruskin was withdrawing these things out of courtesy to the new Professor, for he was most anxious not to appear to be interfering in any way with his teaching methods.

In January 1883 Ruskin was re-elected Slade Professor, and he gave the first lecture of his second tenure on 9th March. It was very well received : 'I was obliged to promise,' he wrote to Mrs. Severn that evening, 'to give the lecture again to-morrow. After lecture I went on to the schools — saw my old Turners.'[2] Gradually, however, his lectures became less and less lucid, and he gave the last on 6th December 1884. Its subject was *Landscape*, but it was largely an angry and muddled tirade, accusing his audience of utterly failing to learn the principles and methods which he had for so many years been trying to teach. Ruskin resigned on 22nd March of the following year, and proceeded to sever his connections with Oxford, which he never again visited.

It was not, however, the failure of his powers as a lecturer which led to Ruskin's resignation. The official reason given by him was a vote by the University on 10th March in favour of vivisection. A contributory factor was his failure a year earlier to persuade the University to purchase two drawings by Turner in the sale of the collection of the late Cosmo Orme at Christie's on 7th March 1884. These two drawings, the *Crook of Lune* and *Kirby Lonsdale*, were purchased by Messrs. Thomas Agnew for £1,155 and £861, respectively. On 2nd March Ruskin had written to Acland : 'The first, and firstest, of all things is to get the Turners, for none other such exist.'[3] Ruskin himself no longer had the resources to buy them; the University authorities also considered themselves too poor, nor did they feel able to finance the improvements in the accommodation of the Ruskin School which Ruskin had asked for at about the same time. As his letters of this period to Dr. Acland clearly show, Ruskin was disgusted. On 23rd October 1883 he had signed a will bequeathing 'to the Bodleian Library his books, his portrait of the Doge Andrea Gritti by Titian, and the choicest of his Turner drawings.'[4] On 4th June 1884, he revoked this bequest.

[1] See note 3 on the preceding page.
[2] *Works*, XXXVII, p. 440.
[3] *Works*, XXXVII, p. 478. Both drawings are still in private collections.
[4] *Works*, XXXIII, p. lvii; the 'Titian' portrait is now in the National Gallery, attributed to Vincenzo Catena.

RUSKIN AS A COLLECTOR OF TURNER DRAWINGS

In 1885 and 1886 Ruskin again campaigned for the return to him of the material 'not in schedule' from the Ruskin School, and he bombarded Alexander Macdonald and Dr. Acland with letters to this effect. In the midst of these exchanges he showed a slight change of heart when he finally presented to the School the important Turner drawing *Sunshine on the Tamar* (below, No. 76), but on the whole he remained firm in his resolve to retrieve as much as possible from Oxford. His interest now was to build up the collections of the St. George's Museum at Sheffield.

Ruskin's remaining Turner drawings were now all assembled at Brantwood. He had sold eleven more at a second sale at Christie's, on the 22nd July 1882.[1] On 29th June 1884 he wrote in his Diary while staying at Brantwood, 'Turners beautifully arranged in bedroom, with *Constance* and *Coblentz* beside *Rouen* and *Goldau* and *St. Gothard*, with *Splügen*, at bedside. *Bolton* so bright in last night's sunset! What shall I do with all my powers and havings, still left?'[2] One has the feeling that these favourite Turner drawings were now his most comforting friends. The last entry in his Diary to mention Turner is indeed a tragic one. On 14th May 1886 Ruskin wrote: 'felt last night as if it was no good to do anything — my Turners themselves all growing dead to me!'[3]

[1] *Works*, XIII, pp. 573–4. [2] *Diaries*, III, p. 1072.
[3] *Diaries*, III, p. 1126.

Turner
as a Draughtsman

In the Introduction to his *Notes* accompanying the Exhibition of his own Turner drawings in 1878, John Ruskin pointed out that Turner's development as a draughtsman can be sub-divided with reasonable accuracy into decades. From 1790 to 1800 he was learning — making widespread use of the example of his British predecessors and contemporaries. Between 1800 and 1810 he consolidated his place as the leading topographical water-colour artist of the day, and was also moving towards the more personal style which came to the fore in the following decade. During those years his mastery of the medium of water-colour became complete, and his palette grew much lighter and more colourful. From 1820 to 1830 his colour and handling continued to become ever more confident, and his own individual style was achieved with complete success. The next ten years saw the full blossoming of this style and the creation of many of the most wonderful of all English water-colours. In the final decade of his life Turner was working largely for his own pleasure and satisfaction; his water-colour technique became wholly free, and the sketches of these last years seem even now to have been a century ahead of their time.

It must be remembered that, except in the first decade, Turner's work in water-colours was very largely subsidiary to that in oils. There was never a direct link between a finished water-colour and an oil painting, though for the compositions of both he depended on the rapid and undetailed pencil notations with which he filled so many small sketch-books. He must nearly always have carried one of these in his pocket, especially when on one of his frequent sketching tours in this country or abroad. In later years he also often carried a roll sketch-book, and in this he would make such breathtaking and fluid on-the-spot studies in water-colours, as *On the Rhine: looking over St. Goar to Katz, from Rheinfels* (No. 84, plate XL).

The catalogue section of this volume consists of entries for one-hundred-and-one drawings, of which ninety-two are firmly attributed to J. M. W. Turner.

The earliest of these dates from 1792, when the artist was seventeen; the latest from about 1842. Thus the collection of his drawings at the Ashmolean Museum spans half a century of Turner's working life and, thanks very largely to the carefully selected gifts of John Ruskin, it provides a broad survey of his achievements as a draughtsman. It does not include, however, any of the larger and more finished water-colours of the 1830s and early 1840s, which are such a striking feature of, for instance, the R. W. Lloyd Bequest at the British Museum.

Turner's first developments as a water-colour artist can be well studied at Oxford. *Craig-y-foel* (No. 88, plate XLIIIA), boldly signed *W. Turner*, was given away as a present during his first Welsh tour in 1792. At this time he was a student at the Royal Academy Schools, but he had also taught himself a great deal by copying after various topographical artists, such as Edward Dayes, whose influence is strongly felt in the firm outlines and carefully toned colours of No. 88. The much more delicate colouring in the drawing of the '*Remains of Abingdon Abbey*' (No. 90, plate I), which dates from about 1793, may reflect the example of Thomas Malton, the younger, under whom Turner is reputed to have studied at about this time. The highly finished *Boats on a Beach* (No. 59, plate II) and the incomplete *Ruined Abbey at Haddington* (No. 60, plate III), which is copied from an engraving after Thomas Hearne, provide further insight into the work of these formative years of the mid-1790s. Another aspect of that work is seen in the precise and detailed pencil drawings made at Chester in 1794 (Nos. 61 and 62, plates XLIIA and XLIIC), and at Oxford at about the same time (No. 89, plate XLIIB).

Turner had exhibited his first water-colour at the Royal Academy in 1790. The '*Transept of Tintern Abbey*' (No. 91, plate V) was one of the eight drawings which he showed five years later, in 1795. This beautiful drawing, with its subtle colouring of greens and greys and its harmonious light effects, shows a tremendous advance over the somewhat crude *Craig-y-foel*. Turner had, by now, completely mastered the traditional technique of the 'tinted' English topographical drawing, which was done in three stages — pencil outline, chiaroscuro washes, and final tinting.

Between about 1794 and 1798 Turner, often in the company of his fellow-artist Thomas Girtin (1775–1802), was frequently at the house in Adelphi Terrace of Dr. Thomas Monro, whom Ruskin described as the young artist's 'true master'. One of the tasks which the doctor set Girtin and Turner, as well as several other artists, was the copying of drawings by J. R. Cozens, and it is said that for an evening's work each artist received half-a-crown and his supper.

Numerous drawings done for Dr. Monro still exist today, but so far it has proved impossible to achieve definite attributions of these sheets to one artist or another. Four such drawings, all formerly attributed to Turner, are here listed as Monro School Copies (Nos. 95 to 98, plates XLVIIID, C, B and A), while for a fifth, the *Mountain Landscape with a Bridge* (No. 64, plate VI), Ruskin's own firm attribution to Turner has been retained. This delicate drawing in blue and grey washes certainly has more individuality than any of the other Monro School Copies at Oxford.

It is rewarding to compare No. 64 with the first of the Oxford Almanack drawings, the '*South View of Christ Church*' (No. 1, plate VII), which dates from 1798 to 1799. The full story of Turner's drawings for the Oxford Almanacks is told separately (pp. 55–58 below), but they must also be referred to here as providing an unrivalled series of Turner's best finished topographical drawings from the years between 1798 and 1804. It should be remembered that the artist had exhibited his first oil painting at the Royal Academy in 1796, was elected an Associate in the late autumn of 1799, and achieved the status of Royal Academician in 1802. His work in oils was now prolific, and already included such masterpieces as *Aeneas and the Sibyl* and *The Fifth Plague of Egypt*. Yet, as his Oxford Almanack drawings prove, Turner was still able and willing to retain his place as an outstanding topographical draughtsman.

A group of rapid pencil, and pencil and wash studies (Nos. 66–70, plates XLIID, F, G, I and E), made during Turner's tour of 1801 in the North of England and Scotland, provide excellent evidence of the great change in Turner's draughtsmanship from the precise outlines of the Chester drawings of 1794 (Nos. 61 and 62, plates XLIIA and C). In the later sketches Turner is making only the roughest of notations; he no longer needs the practice of drawing in detail on the spot — from the 'living' model so-to-speak — but requires only basic notes to remind himself of a particular scene should he later wish or need to record it more fully. The water-colour drawing from this group, *Scarborough* (No. 69, plate XLIII), shows the brilliant application of basic colours over the minimum pencil outline to provide a somewhat more complete notation. The intermediate stage between the widely differing techniques of 1794 and of 1801 may be seen in the single sheet of 1797, *Durham Castle from across the River* (No. 65, plate IV), which is still fairly detailed.

Dating from about 1801 to 1805 are the twelve pages of a dismembered sketch-book (Nos. 11–22, plates XIV, XLIIIG and H, and XLIVA to I), which form part of Ruskin's gift of 1861. Showing scenes in and near Eton College,

several of them on the Thames, these sketches are broadly drawn in black chalk, stumped in places, and heightened with white. The rough paper was originally blue, but has faded to various shades of grey. Ruskin stated that these sheets were at one time in Dr. Monro's collection, and was entirely confident in attributing them to Turner. It has proved difficult to find any close parallels for this series among other drawings, but in feeling and composition these scenes have something in common with the oil sketches which Turner painted on the spot between about 1805 and 1810 at various points on the Thames between Walton and Windsor. In their broad chalk technique the drawings are somewhat reminiscent of Dr. Monro's own style, which was itself strongly influenced by that of Gainsborough.

Also dating from early in the second decade is the *Study of a Group of Cows* (No. 71, plate XIII), which is clearly linked with a sketch-book in the Turner Bequest containing similar water-colour and pencil studies. In this drawing the water-colour has been applied with a very dry brush, and there is a skilful use of scratching out to indicate the highlights on the animals' coats. In the view of *Chester Castle* (No. 93, plate XLIIIF), which probably dates from a few years later, the handling is similarly dry, and there is again some scratching out.

The three drawings of Lowther Castle (Nos. 72–4, plates XV and XLVA and B), which can be firmly dated to 1809, show a much more delicate approach. But though delicate, Turner's pencil line is here entirely confident, and in the drawing which has been partially completed in water-colours (No. 72) we have an excellent example of the direct application of water-colours to the pencil outline, *without* the use of any monochrome washes, as has already been seen in the *Scarborough* of 1801 (No. 69, plate XLIII). The effect of distance has been marvellously achieved, while the detailed study of the thistle in the foreground also shows Turner's complete confidence in the use of water-colours. This is again illustrated by the subtle *Sunshine on the Tamar* (No. 76, colour plate B), which dates from about 1813. Here Turner has reverted to a much drier brush, and in the dark areas in the foreground he has made use of gum arabic to strengthen the tones. The orb of the setting sun is brilliantly rendered by leaving the white paper totally uncovered; elsewhere, as in the sun's reflection, Turner has used scratching out, and he has drawn with the handle of his brush to bring to life the grass in which the pigs are browsing. *Sunshine on the Tamar* superbly combines the overall effect of the scene and its atmosphere with the skilful rendering and incorporation of much precise detail. This combination was to be a feature of Turner's finished water-colours for the next twenty years.

TURNER AS A DRAUGHTSMAN

The sepia *Study of Trees* (No. 75, plate XVI), which was prized by Ruskin as one of his 'very chief Turner treasures', is connected, though not directly, with the artist's work on his *Liber Studiorum*, of which the seventy completed mezzotint plates were published between 1807 and 1819. There are many *Liber Studiorum* drawings in the Turner Bequest and, like No. 75, these reveal his powers of composition aided by fluid and confident draughtsmanship.

During the 'third decade' Turner often stayed at Farnley Hall, the Yorkshire home of his friend and patron, Walter Fawkes. Here he drew not only the house and its surrounding scenery, but also such works as *A Frontispiece* (No. 77, plate XVII), which is dated 1815. Despite its damaged state this drawing is a *tour-de-force* in the use of water-colours, as is the lovely *Sketch of Pheasant* (No. 78, plate XLVc), which was probably also executed while Turner was at Farnley. The plumage of the proud bird, already dulled by death, is beautifully rendered in rather dry colours and much use is made of the cold white of the paper to heighten the effect of these colours. The *Sketch of Mackerel* (No. 80, plate XX) and the *Study of Fish* (No. 81, plate XLVd), which are both a few years later than the *Pheasant*, show a much more fluid and less deliberate use of water-colours, which, especially in the former, results in a convincing impression of the 'wetness' of fish.

Another of Ruskin's great treasures was *The Junction of the Greta and Tees at Rokeby* (No. 79, plate XVIII), which was drawn in about 1816 to 1818 and engraved as one of the plates for Whitaker's *History of Richmondshire*. Though this water-colour, which was in the Dillon Collection, is slightly faded, it retains a wonderful harmony of blues, greens and browns, which is enhanced by a fair amount of scratching out and occasional use of the brush handle to emphasise the foliage in the foreground. In his *Catalogue of the Standard Series* Ruskin described it as 'an unrivalled example of chiaroscuro of the most subtle kind; — obtained by the slightest possible contrasts, and by consummate skill in the management of gradation'.

The next decade of Turner's work as a draughtsman, 1820 to 1830, is again richly represented in Ruskin's gifts. It is instructive to compare the *Greta and Tees* with the much freer and more fluid sea-scape, (?) *Yarmouth* (No. 23, plate XXI), which is probably the earliest of the works of the fourth decade to be seen at Oxford. Here a really wet brush has been used, with equal effect for the fish struggling in the net in the foreground and for the broad sweep of the waves in the rough sea. As in the *Greta and Tees*, the colour range is limited — mainly greys, blues, yellows and browns.

'Comb Martin' (No. 24, plate XIX) and 'Boscastle' (No. 25, plate XLVe),

the two drawings of about 1824 which were engraved for Cooke's *Picturesque Views on the Southern Coast of England*, are more colourful and much more finished. Occasionally a dry stipple effect is used, particularly in the skies, although this may have been achieved by dabbing with a slightly textured material when the pigment was almost dry. From now on it becomes increasingly difficult to be at all certain about the technical methods used by Turner, for these became ever more unorthodox. From about 1820 to the mid-1830s Turner was doing a great deal of work for the engravers, and it was their needs and demands during these years which prevented his water-colour techniques from becoming generally looser and freer. Though drawn not long after the two subjects for the *Southern Coast*, the '*Margate*' (No. 26, plate XLVF), with its brilliant blue sea and its 'scratched' waves, was not, in fact, engraved until after Turner's death; it was used for plate 6 of *The Harbours of England*, for which Ruskin wrote the text. His comments on the drawing are quoted in the *Catalogue* entry. In this water-colour also, much use is made of the surface colour of the paper, originally white, but today somewhat darkened to a pale buff.

In the work done for his own pleasure in the later 1820s and early 1830s Turner's style became increasingly loose and colourful, and he also made more frequent use of body-colour. The series of brilliant interiors drawn at Petworth, the Sussex home of that notable patron, the third Earl of Egremont, dates from these years. So also do the splendid drawings connected with the engravings of *The Rivers of France*, of which twenty-five are at Oxford (Nos. 27, 29–51, and 82). Three separate series of *The Rivers of France* were issued as *Turner's Annual Tours* in 1833, 1834 and 1835: the first year was devoted to the Loire, the other two to the Seine; there were 61 plates in all. Ruskin presented seventeen of the engraved Loire drawings, and eight unengraved studies, including one identified as a *Scene on the Meuse* (No. 27, plate XXVIII) and two views on the Seine (*Harfleur*, No. 30, plate XLVIB; and *Tancarville*, No. 32, plate XXIII). There are some 270 similar drawings and studies in the Turner Bequest (including 36 that were engraved for the two Seine series) — a few further examples from this group are to be found in collections throughout the world.

Drawn on small sheets of fairly rough paper that were originally blue, but are now in most of the Oxford examples faded to grey, these jewel-like compositions combine the assured recording of detail with the superb rendering of atmosphere. When Ruskin was himself on the Seine in August 1882, he wrote in his Diary, 'I have never enough thought out that Turner's work

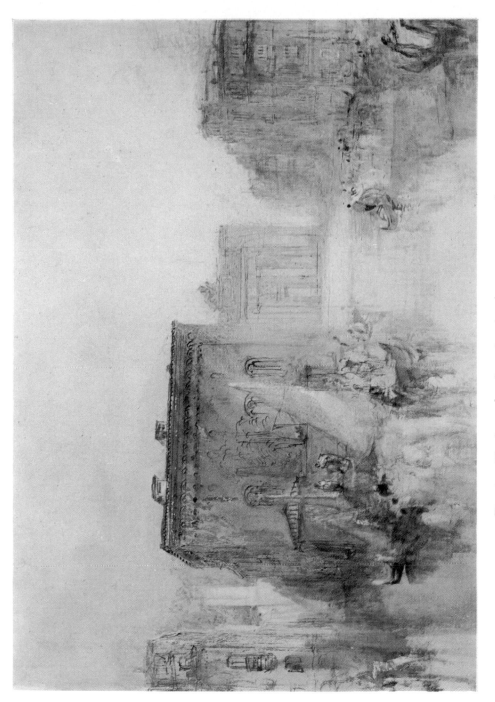

D. 57. Venice : the Accademia. (217 : 318 mm.)

was the "Rivers" of France, not the "towns" of it. How he was the first painting living creature who saw the beauty of a "coteau".' The painting of water, be it in sea, lake or river, was always of special interest and significance to Turner. In most of these drawings the waters of the Loire are shown with fantastic economy; on the whole Turner has merely 'helped' the paper to look like calm water, an effect that must have been even more convincing before the blue paper faded. Outstanding examples of this are the '*Scene on the Loire*' (No. 50, colour plate C) and the '*Beaugency*' (No. 47, plate XXXII).

The most atmospheric of the drawings is undoubtedly another *Scene on the Loire* (No. 82, plate XXII), which Ruskin named as the 'loveliest of all' the Loire series and which was the only one of these drawings included in his gifts to the Ruskin School. In this the paper is still blue, and the misty effect of the calm of evening is beautifully rendered. When Turner required more detail, as in the drawing of buildings, he made frequent and varied use of black, red and other inks to strengthen the outlines and emphasise the features. The '*Orleans*' (No. 48, plate XLVIIB) and the '*Palace at Blois*' (No. 44, plate XXIX) provide striking examples of this. In both these drawings use is also made of body-colour, especially white, to strengthen the highlights. In the vignette drawing of '*Nantes*' (No. 29, plate XXXVI) the use of body-colour, in fact, exceeds that of water-colour; the massive form of the cathedral in the background is rendered almost entirely in white. In other drawings Turner has achieved his effects by scratching out, as, for instance, for the reflection at the base of the cliff in the '*Coteaux de Mauves*' (No. 41, plate XXX).

Throughout the Loire series Turner has left large surfaces of the paper completely uncoloured and untouched, and he uses this method again in the two vignette drawings of about 1832 to 1833, which were engraved for *Byron's Life and Works* (Nos. 52 and 53, plates XXXVII and XLVIID). In these, however, his drawing and colouring are rather nervous and precise, and it is in drawings of this character that Turner's work can, and often does, appear dated. In both these vignettes some use is made of a fine stipple technique; this is rather more in evidence in the two drawings of about 1835, which were engraved for Finden's *Biblical Keepsake* (Nos. 54 and 55, plates XXXV and XLVG). In drawing the rock faces in the former, '*Mount Lebanon and the Convent of St. Antonio*', Turner has again relied largely on the bare surface of the paper to achieve his effect; yet Ruskin's heartfelt praise of the drawing of the rock is totally justified.

By the later 1830s, when he was already over sixty, Turner had almost ceased to work for the engravers, and for the remainder of his life the greater

part of his output in water-colours was done for his own satisfaction and pleasure, and often took the form of rapid on-the-spot sketches. It is extremely difficult to be at all precise in dating most of the work of these last ten years or so, especially as the extent and timing of his continental journeys during these years has not yet been fully ascertained.

Two of these wonderfully fluid water-colour studies at Oxford are of scenes on the Rhine, along which Turner made a number of journeys, the first in 1817. The chief product of that first Rhine tour was the series of fifty-one detailed water-colour compositions of views on the Rhine which Walter Fawkes of Farnley bought for £500. One of these shows almost the same view as No. 84, *On the Rhine: looking over St. Goar to Katz, from Rheinfels* (plate XL). The somewhat deliberate and sombre colours of the Farnley drawing, with its setting sun, are replaced in this later sketch by pale and delicate washes, in which Ruskin especially admired 'the arrangement of glowing colour and the tender depth of shadows that have no gloom in them'. In the second Rhine sketch at Oxford the water-colours are applied with even greater economy and fluidity, again over a rapid pencil outline. These delicate Rhine sketches, of which Ruskin also owned several more, must surely have been drawn on the spot at a time when Turner was in the calmest and most peaceful of moods.

Turner's last visit to Venice, a city which he had first seen in 1819, took place in 1840, and here again he worked in water-colours on the spot. Ruskin described each of the three late Venetian drawings which he gave in 1861 as 'Sketch on the spot', and, though subsequent writers have disputed this description, Ruskin was surely correct. The scintillating colouring and play of light in *The Grand Canal* (No. 56, plate XXXVIII) are completely direct in effect and achieved with the most marvellous economy — pencil, blue, red, minimal touches of white; brilliantly giving depth to the whole composition is the black wash of the gondola. In the other two Venetian sketches, *The Accademia* (No. 57, colour plate D) and *The Riva degli Schiavoni* (No. 58, plate XXXIX), Turner has gone into greater detail and used a much more varied palette, in which red, blue and yellow predominate. Again he has beautifully captured the clear and yet hot light and colours that make Venice the artist's Mecca. All three drawings are vivid impressions of the city, rather than topographical records. In order, however, to provide at least a minimum of architectural detail, Turner has made liberal use of the pen, largely with red ink, to strengthen the outlines.

This detail is wholly lacking in the two latest Turner drawings at Oxford, *Cloud and Sunlight at Sea* (No. 85, plate XLVIIF) and *Evening: Cloud on Mont*

Rigi, seen from Zug (No. 86, plate XLI). Both these wonderful colour impressions are in pure water-colours applied with great rapidity and freedom, and without any trace of pencil outline or use of any other medium. In such water-colour sketches of his last years, so many of which are listed simply as 'Colour Beginnings' or 'Miscellaneous' in the *Inventory* of the Turner Bequest, Turner was making direct, and often unorthodox use of the medium to record fleeting impressions and ideas. At this time he was also achieving similar results in numerous fluid studies in oils, some of which he later worked up into more finished paintings. In these totally free and natural paintings and drawings, Turner was creating some of his most remarkable work. Having achieved complete mastery of the technical problems he could now give free rein to his powers of imagination and vision. It is not surprising that one of the most recent exhibitions devoted to his genius should have been shown, with resounding success, in New York's Museum of Modern Art.

Catalogue of the
Turner Drawings in
the Ashmolean Museum

The drawings are listed in four groups according to the manner of their accession; in each of these groups they are arranged, as far as possible, in chronological order.

Measurements are given in millimetres; the height preceding the width. Unless otherwise described a drawing is on white paper.

CATALOGUE NOS. 1–10

The Oxford Almanack Drawings

The first examples of J. M. W. Turner's work to enter the collection were the ten water-colours which were included in the large group of drawings connected with the Oxford Almanack deposited in the University Galleries by the Delegates of the Clarendon Press in 1850. The first Oxford Almanack was published in 1674, and the subject of the illustration was wholly allegorical. It was not until 1754 that a purely topographical head-piece was printed, and twelve years later the allegorical style was finally abandoned. Among Turner's predecessors in drawing Oxford views for the Almanack were J. B. Malchair, Michael Angelo Rooker and Edward Dayes. There were still drawings by the last named in hand when, in 1798 or 1799, the twenty-four-year-old Turner was commissioned by the Delegates of the Clarendon Press to produce 'two Views for Almanacks', for which the payment of twenty-one guineas is recorded in the *Printing House and Press Account* book for 1799.

The first of these drawings, '*South View of Christ Church, &c. from the Meadows*' (No. 1, plate VII), was used for the Almanack of 1799. It was engraved on copper by James Basire, who was reponsible for all but one of the subsequent head-pieces based on the drawings of Turner. The second subject, '*A View of the Chapel and Hall of Oriel College, &c.*' (No. 2, plate XLIIIE), was used in 1801, the year in which Turner received payment for his third Oxford Almanack drawing, '*Inside View of the East end of Merton College Chapel*' (No. 3, plate VIII), which was engraved as the head-piece for 1802.

The final Edward Dayes drawing was engraved in 1803, and from 1804 to 1808, and again in 1810 and 1811 the subjects were provided by Turner, who received in 1804 the sum of £73. 10. 0. for '7 drawings for Almanacks'. Quite soon after providing his first two Almanack drawings, on 4th November 1799, Turner was elected an Associate of the Royal Academy, and some time before delivering the final group of drawings he was elected an Academician, on 12th February 1802. But Turner's promotion and rapidly growing reputation had no effect on the payment he received from the Clarendon Press, which

55

remained, as it had begun, ten guineas per drawing.[1] It is, perhaps, of interest to note that at their meeting on 18th March 1796 the Delegates of the Clarendon Press 'ordered that Mr. Basire be employed for the future to engrave the Oxford Almanacks at the price of fifty guineas or more in proportion, if there be extraordinary work, besides all incidental expenses'. It is impossible to ascertain exactly how much Basire was, in fact, paid each year for the engraving, for in the *Press Account* book this sum is given as part of the total annual payment to him. This often included very high 'incidental expenses', such as the stamp duty, which at this time was 1/- for each copy of the Almanack.

Not only did his altered status have no effect on the payments made to Turner for his drawings, but it also did nothing to increase the respect with which the authorities of the Clarendon Press treated them. The Minutes of the Delegates' meeting on 16th May 1806 record that 'Mr. Neill [*sic*] be commissioned to sketch more correctly some part of the inside of Christ Church Hall, for the use of the Engraver of the Almanack for the ensuing year'. The results of the alterations sketched by Hugh O'Neill, who was only twenty-two at the time and thus Turner's junior by nine years, are outlined in the catalogue entry for the '*Inside View of the Hall of Christ Church*' (No. 7, plate IX). While these were, in fact, relatively minor changes, the treatment meted out to Turner's drawing of '*Part of Balliol College Quadrangle*' (No. 9, plate XLIIIc), the subject of the head-piece in 1810, was much more drastic. The Clarendon *Press Account* book for 1806 records a payment of £2. 12. 6. 'to Mr. Neill [*sic*] for correcting a Drawing of Balliol College for an Almanack'. The reason given for this action, recorded by W. G. Rawlinson, is that Dr. Parsons, then Master of Balliol and one of the Delegates, refused to sanction the engraving of Turner's drawing, because he considered his placing of the shadows to be incorrect. That Turner himself had difficulties with the shadows

[1] The facts concerning Turner's Oxford Almanack drawings were first published by C. F. Bell in his article 'Turner and his Engravers' in *The Genius of J. M. W. Turner* (*Studio* Special Number, Winter 1903), and given in greater detail in his article on 'The Oxford Almanacks', in the *Art Journal* for August 1904 (pp. 241–7). In Bell's annotated copy of the former (now in the Library of the Victoria and Albert Museum; Reserve Case, P. 10) he has inserted a note claiming that he had made 'a very bad mistake due to misreading of the rather confused entries in the account books of the University Press' in stating that Turner received only ten guineas for each of his Almanack drawings. This undated note adds that 'the payments to Turner were *fifty guineas* and incidental expenses for each drawing'. Careful checking of the Clarendon *Press Account* book has, however, entirely confirmed the original interpretation of payments of ten guineas for each drawing.

is shown by the *pentimenti* in the drawing at the sides of the buttresses of the Old Hall. It appears, however, that O'Neill must have produced a fresh drawing closely based on Turner's rendering of this scene, and it was O'Neill's name that was printed as the artist of the 1810 head-piece, which was the first, and last, to be engraved by James Storer. The four subsequent Almanacks, of which only the first was after Turner, were again engraved by James Basire, who was finally replaced in 1815 by Joseph Skelton.

It is tempting to surmise that Basire actually declined to engrave O'Neill's drawing for 1810; surviving proofs of the 1811 head-piece, *'View of the Cathedral of Christ Church, and Part of Corpus Christi College'* (No. 10, plate XLIIID), provide clear evidence of a close working relationship between Basire and Turner (see *Rawlinson*, I, p. 19, No. 47). The story of the engraving of Turner's Oxford Almanack drawings is somewhat confused by the fact that there were two engravers named James Basire, father and son, who might both have been concerned. While the entry for the Basire family in the *Dictionary of National Biography* takes it for granted that the elder James Basire (1730–1802) received the Almanack contract in 1796 and executed the work until his death, C. F. Bell, in his 1904 article, gives the credit for engraving all the Turner drawings to the son, who was born in 1769 and died in 1822. Though the question of who exactly engraved the first three head-pieces after Turner must remain a matter of conjecture, there can be no doubt that the younger James Basire (whose own son, another James and also an engraver, was only born in 1796) was responsible for all the following Almanacks which bore Turner's name. The second James Basire, who was some five years older than Turner, carried on the business and continued faithfully to practise the methods of his father, whom he succeeded as engraver to the Society of Antiquaries. However, in 1806, the Savilian Professor of Astronomy complained bitterly to the Delegates about Basire's inefficient work on the Almanacks, and it was ordered that two of Turner's drawings, 'the one a View from Headington Hill [No. 8] and the other of the Fellows' Building etc. of Corpus College [No. 10], be now put into his [Basire's] hands expressly for purpose of further trial'. The Minutes record no further qualms about Basire's work and his trial plates presumably satisfied the Delegates, though they were not actually used until 1808 and 1811, respectively.

Though deposited in the University Galleries in 1850, the earliest evidence that the Turner drawings were exhibited occurs in the 1870 edition of the *Handbook Guide of the University Galleries*, which describes them hanging in the Ante Room, which also housed 'Mr. Ruskin's Gift' of 1861 in 'Two

Costly Cabinets'. There is no mention of the drawings in the five preceding editions of the *Handbook* (1850, 1853, 1857, 1859 and 1865).[1]

Ruskin's only recorded reference to these Turner drawings appears in the *Ariadne Florentina* lectures, delivered at Oxford in Michaelmas Term, 1872. At the end of the fifth lecture, which was entitled *Design in the German Schools of Engraving*, Ruskin devoted a paragraph to severe criticism of the English School of engraving, which included in parentheses the sentence: 'One fortunate exception, gentlemen, you have in the old drawings for your Oxford Almanack, though the publishers, I have no doubt, even in that case, employed the cheapest artist they could find' (*Works*, XXII, pp. 419–20). For the published version, first issued in 1875, an explanatory foot-note was added, which began, 'The drawings were made by Turner, and are now among the chief treasures of the Oxford Galleries.'

Several of these Almanack drawings, especially Nos. 6 and 10, have been considerably damaged, presumably when in the hands of the engravers, and most of them are somewhat faded and rubbed. In some of the water-colours the buildings in the background appear much fainter than they are in the engravings. An outstanding example of this is No. 5, '*A View from the Inside of Brazen Nose College Quadrangle*' (plate X); in the engraving the dome of the Radcliffe Camera and the spire of St. Mary's are rendered with much more emphasis than they are in the drawing.

It has sometimes been presumed that the smaller versions of the Oxford Almanack engravings published by Joseph Skelton in his *Oxonia Antiqua Restaurata* were based, certainly in the case of those after Turner, on the original drawings. There is, however, absolute proof that they were copied from the engraved head-pieces, of which Skelton must have had a complete run at his disposal.

1. (VII) '*South View of Christ Church, &c. from the Meadows*'.

Water-colours, with some pen and black ink, over pencil; 315 : 451 (the drawing has several scratches and other blemishes).

Deposited by the Delegates of the Clarendon Press in 1850.

Date 1798–9. Probably based on the slightly smaller pencil study on folio 2 of the '*Smaller Fonthill*' Sketch Book (*Inventory*, No. XLVIII), which is water-

[1] The ten drawings are listed on p. 269 of Sir Walter Armstrong's *Turner*, 1902.

marked 1794, as is a second similar, but considerably smaller pencil view also among the Turner Bequest drawings (*Inventory*, No. L, sheet Q). The same view in water-colours, with the silhouette effect of dusk or dawn, is to be found among the miscellaneous water-colours (*Inventory*, No. CXXI, sheet G) dated by Finberg 1802–10.

No. 1 was engraved (s.s.) by James Basire as the head-piece of the Oxford Almanack of 1799 (*Rawlinson*, I, p. 14, No. 38; II, p. 188); this engraving was copied in smaller size by Joseph Skelton for his *Oxonia Antiqua Restaurata*, 1823 (Vol. II, plate 99, dated 1816; *Rawlinson*, I, p. 20, No. 38a). The drawing was reproduced (s.s.) by chromo-lithography as the head-piece of the Oxford Almanack for 1913; among other reproductions are: M. Butlin, *Turner Watercolours*, 1962, pl. 1; L. Herrmann, *J. M. W. Turner*, 1963, pl. 1. Exhibited; Burlington House, *British Art*, 1934, No. 714; *Commemorative Catalogue*, No. 758.

2. (XLIIIE) *'A View of the Chapel and Hall of Oriel College, &c.'*
Water-colours over pencil; 312 : 440 (the drawing bears a number of blemishes, and has been slightly cut at both sides).

Signed *W. Turner* in ink at L. lower corner; to R. of the signature are traces of a further inscription, cut away.

Deposited by the Delegates of the Clarendon Press in 1850.

Date 1798–9; engraved (s.s.) by James Basire as the head-piece for the Oxford Almanack of 1801 (*Rawlinson*, I, p. 15, No. 39; II, p. 188); this engraving was copied in smaller size by Joseph Skelton for his *Oxonia Antiqua Restaurata*, 1823 (Vol. II, plate 101, dated 1816; *Rawlinson*, I, p. 20, No. 39a).

3. (VIII) *'Inside View of the East end of Merton College Chapel'.*
Water-colours over pencil, with some scratching out; 318 : 444 (there are a few minor paint losses).

Deposited by the Delegates of the Clarendon Press in 1850.

Date 1801; under that year the payment of 10 guineas to 'Turner for a View of the inside of Merton Chapel' is recorded in the *Printing House and Press Account* of the Clarendon Press. The drawing was engraved (s.s.) by James Basire as the head-piece for the Oxford Almanack of 1802 (*Rawlinson*, I, p. 16, No. 40; II, p. 188); the engraving omits the figure to the left of the altar, which appears in the drawing to be legless. A smaller version of the engraving, dated 1817, is included as plate 102 in Vol. II of Joseph Skelton's *Oxonia Antiqua Restaurata*, 1823 (*Rawlinson*, I, p. 20, No. 40a).

CATALOGUE

4. (Colour Plate A) '*A View of Worcester College, &c.*'

Water-colours over pencil; 320 : 443 (there are some slight damages in the sky).

There are traces of a signature, starting *J.M.W.*, in the R. lower corner.

Deposited by the Delegates of the Clarendon Press in 1850.

Date 1803–4; engraved (s.s.) by James Basire as the head-piece for the Oxford Almanack of 1804 (*Rawlinson*, I, p. 16, No. 41; II, p. 188); this engraving was copied in smaller size by Joseph Skelton for his *Oxonia Antiqua Restaurata*, 1823 (Vol. II, plate 104, dated 1820; *Rawlinson*, I, p. 20, No. 41a). In the engraving the storm-clouds on the R. are greatly accentuated, and the shadows in R. foreground and middle distance are deepened, while the Observatory is highlighted.

5. (X) '*A View from the Inside of Brazen Nose College Quadrangle*'.

Water-colours over pencil; 316 : 446 (there are a number of damages in the sky and elsewhere).

Deposited by the Delegates of the Clarendon Press in 1850.

Date 1803–4; engraved (s.s.) by James Basire as the head-piece for the Oxford Almanack of 1805 (*Rawlinson*, I, p. 17, No. 42; II, p. 188); this engraving was copied in smaller size by Joseph Skelton for his *Oxonia Antiqua Restaurata*, 1823 (Vol. II, plate 105, dated 1818; *Rawlinson*, I, p. 20, No. 42a). The drawing was reproduced (s.s.) by chromo-lithography as the head-piece for the Oxford Almanack of 1917.

The statue, a copy in lead of the marble group of *Samson slaying the Philistine* by Giovanni Bologna, of which the original is now in the Victoria and Albert Museum (A.7–1954), was presented to the college by Dr. George Clarke in 1727, and was removed from its place in the Old Quadrangle in 1881.

6. (XI) '*View of Exeter College, All Saints Church &c. from the Turl*'.

Water-colours over pencil; 321 : 450 (there are several tears and a number of other blemishes).

Deposited by the Delegates of the Clarendon Press in 1850.

Date 1802–4; engraved (s.s.) by James Basire as the head-piece for the Oxford Almanack of 1806 (*Rawlinson*, I, p. 17, No. 43; II, p. 188); this engraving was copied in smaller size by Joseph Skelton for his *Oxonia Antiqua Restaurata*, 1823 (Vol. II, plate 106, dated 1818; *Rawlinson*, I, p. 20, No. 43a). The hatchment over the gate of Jesus College has been omitted in the engraving. Its inclusion in the drawing suggests that this, or at any rate the

sketch on which it was based, must have been executed shortly after the death in 1802 of the Principal, Dr. Joseph Hoare, whose successor, Dr. David Hughes, was elected on 20th June of the same year.

7. (IX) *'Inside View of the Hall of Christ Church'*.

Water-colours over pencil, with much scratching out; 329 : 448 (the drawing has one or two minor blemishes and paint losses).

Deposited by the Delegates of the Clarendon Press in 1850.

Date 1803–4; probably based on a large pencil drawing (*Inventory*, No. L, sheet J) in the Turner Bequest, which shows the inside of the Hall from a point very slightly further to the L. No. 7 was engraved (s.s.) by James Basire as the head-piece for the Oxford Almanack of 1807 (*Rawlinson*, I, p. 18, No. 44; II, p. 188). The Minutes of the Delegates of the Clarendon Press for their meeting on 16th May 1806 record that 'Mr. Neill [*sic*] be commissioned to sketch more correctly some parts of the inside of Christ Church Hall, for the use of the Engraver of the Almanack for the ensuing year'. The Press accounts for 1807 record the payment of £16. 5. 6. to 'Mr. Neill [*sic*,] Sketches of Ch. Ch. Hall, & Oxford from Headington Hill & St. Peter's Church'. The chief difference between the present drawing and the engraving lies in the fact that many of the portraits have been enlarged and made more recognisable, and some of the frames more distinct. The bottles etc. on the tables have been omitted. A smaller version of the engraving, dated 1822, is included as plate 107 in Vol. II of Joseph Skelton's *Oxonia Antiqua Restaurata*, 1823 (*Rawlinson*, I, p. 20, No. 44a). The drawing was reproduced (s.s.) by chromo-lithography as the head-piece for the Oxford Almanack of 1916.

The 'Mr. Neill' who assisted in the corrections was Hugh O'Neill (1784–1824), whose own drawings were engraved as the head-pieces for the Almanacks of 1809, 1812, 1813 and 1814. These drawings are also among those deposited by the Delegates of the Clarendon Press in the Ashmolean Museum, and show this artist's work to have been able though somewhat lifeless.

8. (XII) *'A View of Oxford from the South Side of Heddington* [sic] *Hill'*.

Water-colours over pencil, with some scratching out; 316 : 448 (the drawing is much faded and considerably rubbed).

Deposited by the Delegates of the Clarendon Press in 1850.

Date 1803–4; on folio 37 of the *'Fonthill' Sketch Book* in the Turner Bequest (*Inventory*, No. XLVII), which was in use from 1799 to 1804, there is a slight

pencil study of this view of Oxford, concentrating mainly on the skyline. No. 8 was engraved by James Basire as the head-piece for the Oxford Almanack of 1808 (*Rawlinson*, I, p. 18, No. 45; II, p. 188). Though not differing from the drawing in its details (except for the omission of the word *OXFORD* on the door of the coach), the engraving is considerably stronger and sharper than the drawing, and further improves the composition by accentuating the mass of clouds in the centre of the sky; Rawlinson (*loc. cit.*) is entirely justified in describing it 'as an extremely clever piece of engraving', though the present contrast between the drawing and the plate is partially due to the faded condition of the former. A smaller version of the engraving, dated 1820, was included as plate 108 in Vol. II of Joseph Skelton's *Oxonia Antiqua Restaurata*, 1823 (*Rawlinson*, I, p. 20, No. 45a). The drawing was reproduced by chromo-lithography as the head-piece for the Oxford Almanack of 1915. Exhibited: Whitechapel Art Gallery, *J. M. W. Turner*, 1953, No. 144.

9. (XLIIIc) *'Part of Balliol College Quadrangle'*.
Water-colours over pencil; 318 : 447.
Deposited by the Delegates of the Clarendon Press in 1850.
Date 1803–4; the composition resembles the head-piece engraved by J. Storer after H. O'Neill for the Oxford Almanack of 1810. The latter, however, includes part of the N. side of the Quadrangle, while the S. side is entirely in shadow and the buildings on the W. side are considerably lower; the figures and foreground accessories are also altered. Although the Clarendon *Press Account* book for 1806 records a payment of £2. 12. 6. 'to Mr. Neill [*sic*] for correcting a Drawing of Balliol College for an Almanack', the condition of the present drawing suggests that O'Neill produced an alternative drawing, closely based on the rejected drawing by Turner. This would also account for the fact that O'Neill's, rather than Turner's name was attached to the engraving. Tradition has it that Dr. John Parsons, Master of Balliol from 1798 to 1819 and a Delegate of the Press, 'refused to sanction the publication of Turner's drawing in its original state, because he considered that the position of the sun, indicated by the shadows in the picture, was impossible' (C. F. Bell, 'The Oxford Almanacks', in *Art Journal*, August 1904, p. 243; and *Rawlinson*, I, p. xx and p. 19, No. 46).

10. (XLIIID) *'View of the Cathedral of Christ Church, and Part of Corpus Christi College'*.

Water-colours over pencil; 316 : 447 (there are a number of holes at various places in the drawing, especially in the upper part, which have been restored and the missing parts of the design added).

Deposited by the Delegates of the Clarendon Press in 1850.

Date 1803–4; engraved (s.s.) by James Basire as the head-piece for the Oxford Almanack of 1811 (*Rawlinson*, I, p. 19, No. 47; II, p. 188). In the engraving the two small towers at the end of the North transept of the Cathedral have been moved slightly to L. to avoid the overlapping with Tom Tower, and the whole design has been considerably strengthened (to its advantage) — in particular the drawing of the Cathedral tower has been improved. A smaller version of the engraving, dated 1820, is included as plate 111 in Vol. II of Joseph Skelton's *Oxonia Antiqua Restaurata*, 1823 (*Rawlinson*, I, p. 20, No. 47a).

CATALOGUE NOS. 11-58

Drawings presented
by John Ruskin in 1861

The original list of this gift, in Ruskin's own hand, is preserved in the archives of the Department of Western Art at the Ashmolean Museum. The following concordance relates the numbers of the drawings in that list to their catalogue numbers below.

Ruskin List No.	Catalogue No.	Ruskin List No.	Catalogue No.
1	54	20	29
2	55	21	50
3	24	22	31
4	25	23	41
5	26	24	46
6	56	25	43
7	57	26	38
8	58	27	35
9	23	28	47
10	52	29	49
11	53	30	42
12	27	31	44
13	34	32	45
14	36	33	48
15	32	34	51
16	30	35	39
17	33	36	40
18	37	37-50	11-22
19	28		

(11–22) *Twelve Pages of a dismembered Sketch-Book.*

Each page has been clipped along the edges: the sizes therefore differ appreciably. The colour of the paper, too, varies (except at the edges) from a pale blue to a yellowish drab. Originally the pages were uniformly blue, but now they are all more or less discoloured, in some cases very badly; and it is only at the edges, where they have been protected from the light by an overthrow mount, that the original colour has been preserved. The medium of the drawings is throughout a combination of black chalk (stumped in places) with white chalk. The sequence below is arbitrary.

Collections: Dr. Monro; Ruskin.

Presented by Mr. John Ruskin in 1861.

11. (XLIVв) *Two Views of Eton College.*

283 : 220 (paper somewhat faded).

The sheet is divided vertically. The top half is a view of the College from Keate's Lane, with Carter House to the R., and Evans's on the extreme R.; the lower half shows the Long Walk and College Chapel.

12. (XIV) *Eton College from Fifteen Arch Bridge (on the Slough Road).*

206 : 270 (paper very much faded).

13. (XLIIIɢ) *The Cloisters, Eton College.*

219 : 281 (paper somewhat faded).

This view (including the pump) is substantially the same today; the sketch is badly out of drawing, especially on the R.

14. (XLIIIн) *Barnes Pool, Eton, with Baldwin's Bridge.*

211 : 272 (paper very much faded).

Until it was filled in in 1842, Barnes Pool was a navigable arm of the Thames, including a wharf. The bridge shown is presumably that built in 1687, which was replaced by the present iron structure in 1884. The building on the L. is Tom Brown's, the tailors, established on this site in 1797, and rebuilt in 1865.

15. (XLIVн) *Barnes Pool, Eton.*

210 : 276 (paper very much faded).

A more distant view than in the preceding drawing.

16. (XLIVɢ) *A Punt moored in Barnes Pool, Eton.*
 210 : 272 (paper very much faded).
The building in L. background is probably Baldwin's Shore, with Baldwin's Bec and Baldwin's End adjoining it. This sketch clearly shows the channel which connected the Pool with the river.

17. (XLIVᴅ) *A Sluice on the Thames near Eton.*
 222 : 286 (paper much faded, and somewhat foxed).
This may be on Romney Ait, but is not readily identifiable (see note to the following drawing).

18. (XLIVᴀ) *Two Views on the Thames, near Eton.*
 284 : 222 (paper somewhat faded).
The sheet is divided vertically. At the top is a view of what may have been the old sluice, now replaced by Romney Weir; at the bottom is a view of Eton College from Romney Ait, the building being the part of the College then occupied by the Head Master and Fellows. At Romney Ait, which is opposite the College, the Thames divides into three channels, one of which (a new 'cut' of 1797) is provided with a lock. The whole area of the Ait was extensively altered in 1869, which makes exact identification of these drawings difficult.

19. (XLIVᴄ) *Two Views on the Thames, near Eton.*
 269 : 206 (paper very much faded).
The sheet is divided vertically; neither sketch provides sufficient detail to make identification possible.

20. (XLIVꜰ) *The Hulk of a damaged Sailing Boat.*
 204 : 271 (paper very much faded).

21. (XLIVᴇ) *A Stable Yard with a Cart in Centre.*
 207 : 271 (paper very much faded).

22. (XLIVɪ) *A Road shaded by large Trees.*
 208 : 271 (paper very much faded).

Date about 1801–5. The broad and loose technique of these drawings resembles that in many of the sheets of the *Grenoble Sketch Book* (*Inventory*, No. LXXIV), which dates from Turner's first visit to the Continent in 1802.

The engraving in W. Byrne's *Britannia Depicta* of *Eton, from the Slough Road*, after a drawing by Turner, is dated 1st July 1803. The characteristics and dating of these somewhat unusual sketch-book sheets are further discussed above on pp. 45–46. These drawings were Nos. 37–50 in the original list of Ruskin's 1861 gift; and are Nos. 37–40 in the list given on pp. 559–60 of Vol. XIII of the *Works*, which was taken from pp. 59–61 of the *Provisional Catalogue . . . University Galleries, Oxford*, 1891. The reduction from the fourteen drawings recorded in 1861 to the present twelve sheets was first noted in 1896. The detailed information concerning the scenes in or near Eton College has been most generously provided by Mr. Anthony Ray.

23. (XXI) *(?) Yarmouth, Norfolk.*

Water-colours over slight pencil indications, with some scratching out; 242 : 358.

Presented by Mr. John Ruskin in 1861.

Date about 1820–30; the drawing was not engraved and there is no preliminary drawing in the Turner Bequest. It was No. 9 in the original list of Ruskin's 1861 gift; and is No. 5 in the list given on pp. 559–60 of Vol. XIII of the *Works*. Exhibited: Whitechapel Art Gallery, *J. M. W. Turner*, 1953, No. 155.

In his Diary for 25th January 1857, Ruskin recorded 'stupid anxiety whether I should take, or leave, or exchange pictures (namely *Calais Sands*, grey *Yarmouth* net, blue *Genoa* &c.)' (*Diaries*, Vol. II, p. 526). Ruskin exchanged the present drawing, but soon bought it back (see note to No. 27 below).

24. (XIX) *'Comb Martin' (Devonshire).*

Water-colours over pencil, with some pen and ink; 146 : 232.

Collections: McCrachen (Christie's Sale, 8th May 1855, lot 79); Ruskin.

Presented by Mr. John Ruskin in 1861.

Date about 1824; probably based on the rough pencil sketch, lacking all the foreground details, on folio 147 of the *Devonshire Coast No. 1 Sketch Book* (*Inventory*, No. CXXIII), which Turner used in about 1811. No. 24 was engraved on copper (s.s.) by William Miller for part XIV of Cooke's *Picturesque Views on the Southern Coast of England*. The plate is dated 1st January 1825, and is incorporated as No. 76 in Vol. II of the bound series published in 1826 (see *Rawlinson*, I, p. 64, No. 119; II, p. 191); a small sailing vessel in the bay, and two masts at extreme R. have been added, and several other modifications have been made. A touched proof in the Bullard Collection in the Museum of Fine Arts, Boston, Mass., suggests that these

alterations were proposed by Turner himself (see Finberg, *An Introduction to Turner's Southern Coast*, 1929, p. 57). The drawing was No. 3 in the original list of Ruskin's 1861 gift; and is No. 35 in the list given on pp. 559–60 of Vol. XIII of the *Works*.

In his third letter of March 1861 to Dr. Acland (see p. 33) Ruskin stated that he had paid 80 guineas for the '*Comb Martin*', and that it would fetch 'at least 100'.

25. (XLVE) '*Boscastle, Cornwall*'.
 Water-colours over pencil, with pen and ink; 142 : 231.
 Presented by Mr. John Ruskin in 1861.
 Date about 1824; probably based on the very rough pencil sketch of this view, without the ships, on folio 182 of the *Devonshire Coast No. 1 Sketch Book* (*Inventory*, No. CXXIII), which Turner used in about 1811. No. 25 was engraved on copper (s.s.) by Edward Goodall for part XIV of Cooke's *Picturesque Views on the Southern Coast of England*. The plate is dated 10th March 1825, and is incorporated as No. 73 in Vol. II of the bound series published in 1826 (see *Rawlinson*, I, p. 65, No. 121 — there described as 'one of the finest plates of the Series'; II, p. 191; and Finberg, *An Introduction to Turner's Southern Coast*, 1929, p. 61). The drawing was No. 4 in the original list of Ruskin's 1861 gift; and is No. 36 in the list given on pp. 559–60 of Vol. XIII of the *Works*. Exhibited: Whitechapel Art Gallery, *J. M. W. Turner*, 1953, No. 164.

 In his third letter of March 1861 to Dr. Acland (see p. 33) Ruskin stated that he had paid 80 guineas for the '*Boscastle*', and that it would fetch 'at least 100'. In his text to *The Harbours of England* Ruskin names Boscastle as one of 'the finest subjects of the Southern Coast series' (*Works*, XIII, p. 61).

26. (XLVF) '*Margate*' (*Kent*).
 Water-colours, with scratching out; 154 : 255.
 Presented by Mr. John Ruskin in 1861.
 Date 1826–8; engraved (s.s.) in mezzotint by Thomas Lupton as plate 6 of *The Harbours of England*, which was published in 1856 with an 'illustrative text' by Ruskin (*Rawlinson*, II, p. 378, No. 785). In his note on this plate, which renders the scene with a much more stormy sky and threatening light effect than the drawing, Ruskin stated that 'it was left unfinished at his [Turner's] death, and I would not allow it to be touched afterwards, desiring that the series should remain as far as possible in an authentic state' (*loc. cit.*,

p. 39; *Works*, XIII, p. 60). The plate was one of those *not* used in *The Ports of England* series, 1826–8, which ceased after the publication of only six plates. With the exception of the foreground details, this view of Margate is very similar to that in the plate devoted to the resort in the *Southern Coast* series (engraved on copper by George Cooke, dated 1824; see *Rawlinson*, I, p. 60, No. 113). The drawing was No. 5 in the original list of Ruskin's 1861 gift; and is No. 6 in the list given on pp. 559–60 of Vol. XIII of the *Works*. Ruskin paid 70 guineas for it (see p. 34).

In the note already referred to Ruskin wrote as follows of the plate: '[it] is not, at first sight, one of the most striking of the series; but it is very beautiful, and highly characteristic of Turner. First, in its choice of subjects: for it seems very notably capricious in a painter eminently capable of rendering scenes of sublimity and mystery, to devote himself to the delineation of one of the most prosaic of English watering-places — not once or twice, but in a series of elaborate drawings, of which this is the fourth. The first appeared in the Southern Coast series, and was followed by an elaborate drawing on a large scale, with a beautiful sunrise; then came another careful and very beautiful drawing in the England and Wales series; and finally this, which is a sort of poetical abstract of the first. Now, if we enumerate the English ports one by one, from Berwick to Whitehaven, round the island, there will hardly be found another so utterly devoid of all picturesque or romantic interest as Margate. Nearly all have some steep eminence of down or cliff, some pretty retiring dingle, some roughness of old harbour or straggling fisher-hamlet, some fragment of castle or abbey on the heights above, capable of becoming a leading point in a picture; but Margate is simply a mass of modern parades and streets, with a little bit of chalk cliff, an orderly pier, and some bathing-machines. Turner never conceives it as anything else; and yet for the sake of this simple vision, again and again he quits all higher thoughts. The beautiful bays of Northern Devon and Cornwall he never painted but once, and that very imperfectly. The finest subjects of the Southern Coast series — the Minehead, Clovelly, Ilfracombe, Watchet, East and West Looe, Tintagel, Boscastle — he never touched again; but he repeated Ramsgate, Deal, Dover, and Margate, I know not how often.

'Whether his desire for popularity, which, in spite of his occasional rough defiances of public opinion, was always great, led him to the selection of those subjects which he thought might meet with most acceptance from a large class of the London public, or whether he had himself more pleasurable associations connected with these places than with others, I know not; but the fact of the

choice itself is a very mournful one, considered with respect to the future interests of art. There is only this one point to be remembered, as tending to lessen our regret, that it is possible Turner might have felt the necessity of compelling himself sometimes to dwell on the most familiar and prosaic scenery, in order to prevent his becoming so much accustomed to that of a higher class as to diminish his enthusiasm in its presence. . . .

'The whole of the drawing is well executed, and free from fault or affectation except perhaps in the somewhat confused curlings of the near sea. I had much rather have seen it breaking in the usual straightforward way. The brilliant white of the piece of chalk cliff is evidently one of the principal aims of the composition. In the drawing the sea is throughout of a dark fresh blue, the sky greyish blue, and the grass on the top of the cliffs a little sunburnt, the cliffs themselves being left in the almost untouched white of the paper.'

27. (XXVIII) *Scene on the Meuse.*
Water-colours and body-colour, with pen and reddish and brown ink, on grey paper; 134 : 186.

Presented by Mr. John Ruskin in 1861.

Date about 1826–30; there is some doubt about the locality of the scene shown in No. 27, which was not engraved. It was No. 12 in the original list of Ruskin's 1861 gift; and is No. 25 in the list given on pp. 559–60 of Vol. XIII of the *Works*. Exhibited: Whitechapel Art Gallery, *J. M. W. Turner*, 1953, No. 169.

In his third letter of March 1861 to Dr. Acland, Ruskin wrote at some length of the present drawing; '[it] is as peculiar as it is masterly — but its price is of course absurd. I wanted it for a long time, and at last got it from its possessor (Mrs. Cooper, wife of master at St. Paul's) for 50 g. — on the condition that she might claim it again for the same sum when she chose. I didn't like the condition, and offered her the sketch No. 9 [No. 23 above], for which I had given 40 g., if she would give up the Meuse finally. She accepting; tired of the Yarmouth, which I ransomed for 30 — the two drawings thus finally costing me the one 80 — the other 40 — but I've marked the Meuse only 70, as there was 10 guineas' worth of mere gift in the matter' (see p. 33).

28. (XLVIA) *Coast of Genoa.*
On the *verso* is a small sketch, in pencil heightened with white, of a town below and on top of cliffs, with a tall tower (? lighthouse) on rocks to L. This could be the harbour of Genoa.

Water-colours and body-colour, with pen and red, blue and brownish ink, and some scratching out, on grey paper; 138 : 180.

Presented by Mr. John Ruskin in 1861.

Date about 1828–30; the drawing, which was not engraved, was No. 19 in the original list of Ruskin's 1861 gift; and is No. 7 in the list given on pp. 559–560 of Vol. XIII of the *Works*. The *Coast of Genoa Sketch Book* in the Turner Bequest (*Inventory*, No. CCXXXII) is dated 1828. Ruskin referred to this drawing in his Diary on 25th January 1857 (see note to No. 23 above).

29. (XXXVI) '*Nantes*' (*Vignette*).

Water-colours and body-colour, with penwork in black and brown inks, on grey paper; 186 : 134.

Presented by Mr. John Ruskin in 1861.

Date about 1830. This vignette is based on a slight pencil sketch of the same view on the L. half of folio 61a in the '*Morlaise to Nantes*' *Sketch Book* (*Inventory*, No. CCXLVII). It was engraved on steel, somewhat reduced, by W. Miller, as the Vignette Title of *Turner's Annual Tour — The Loire*, 1833; this was subsequently reprinted several times (see *Rawlinson*, II, p. 257, No. 432). This drawing was No. 20 in the original list of Ruskin's 1861 gift, and is No. 17 in the list given on pp. 559–60 of Vol. XIII of the *Works*.

No. 29, and the following twenty-two drawings, of which seventeen were engraved for the Loire series of 1833, formed the nucleus around which Ruskin selected his gift of 1861, and they remain today the outstanding feature of the Turner collection at Oxford. The significance of these drawings in Turner's development as a draughtsman is discussed on pp. 48–49 above. The story of their acquisition by Ruskin is fully told on pp. 28–29. The order in which Nos. 29 to 51 are listed here has largely been dictated by the way in which they are mounted. As has been explained on p. 29, the paper on which these drawings are executed was originally blue, and must have faded to the present grey *before* they were purchased by Ruskin in 1858. In this and the following *Catalogue* entries the present colour of the paper is described.

30. (XLVIB) *Harfleur*.

Water-colours and body-colour, with pen and black and brown ink, on grey paper; 134 : 185.

Presented by Mr. John Ruskin in 1861.

Date about 1830; the drawing was not engraved, and differs greatly from

the view in the Turner Bequest (*Inventory*, No. CCLIX, No. 102), which was engraved by J. Cousen for *Turner's Annual Tour — The Seine*, 1834 (*Rawlinson*, II, p. 266, No. 457). The drawing was No. 16 in the original list of Ruskin's 1861 gift; and is No. 21 in the list given on pp. 559–60 of Vol. XIII of the *Works*. Exhibited : Whitechapel Art Gallery, *J. M. W. Turner*, 1953, No. 170.

31. (XLVIc) '*Between Clairmont and Mauves*'.
 Water-colours and body-colour, touched with the pen and with considerable scratching out, on faded grey paper; 138 : 189.
 Presented by Mr. John Ruskin in 1861.
 Date about 1830; engraved on steel, somewhat reduced and with a more sombre overall effect, by W. Miller, for *Turner's Annual Tour — The Loire*, 1833; this plate was subsequently reprinted several times (see *Rawlinson*, II, p. 263, No. 447). The drawing was No. 22 in the original list of Ruskin's 1861 gift; and is No. 18 in the list given on pp. 559–60 of Vol. XIII of the *Works*.

32. (XXIII) *Tancarville*.
 Water-colours and body-colour, with pen and brown ink, on grey paper; 135 : 188.
 Presented by Mr. John Ruskin in 1861.
 Date about 1830; the drawing was not engraved for *Turner's Annual Tour – The Seine*, 1834, in which two other views of Tancarville, one from the front and one from above, were, however, included (*Rawlinson*, II, p. 266, Nos. 458 and 459). The drawings for both of these are in the Turner Bequest (*Inventory*, No. CCLIX, Nos. 128 and 130). The present drawing was No. 15 in the original list of Ruskin's 1861 gift; and is No. 3 in the list given on pp. 559–60 of Vol. XIII of the *Works*.

33. (XXIV) *Calm on the Loire (?near Nantes)*.
 Water-colours and body-colour, with pen and brown ink, on grey paper; 138 : 188.
 Presented by Mr. John Ruskin in 1861.
 Date about 1830; not engraved. The drawing was No. 17 in the original list of Ruskin's 1861 gift; and is No. 4 in the list given on pp. 559–60 of Vol. XIII of the *Works*. A slight indication, near centre, of a large church with twin towers seems to confirm the description *near Nantes*, given in the 1861 list.

In his third letter of March 1861 to Dr. Acland, Ruskin referred as follows to No. 33: 'though containing hardly half-an-hour's work, [it] is so first-rate that I would have given *anything* for it — I *gave* 50, but of course in the market it would bring only 30 or 35' (see above, p. 33).

34. (XXV) *The Bridge at Blois: Fog clearing*.

Water-colours and body-colour, with pen and red and black ink, on grey paper; 131 : 187.

Presented by Mr. John Ruskin in 1861.

Date about 1830; probably based on a slight pencil sketch on folio 19 of the *'Loire, Tours, Orleans, and Paris' Sketch Book* (*Inventory*, No. CCXLIX). No. 34 was not engraved; it was No. 13 in the original list of Ruskin's 1861 gift; and is No. 24 in the list given on pp. 559–60 of Vol. XIII of the *Works*.

35. (XXVII) *'Château of Amboise'*.

Water-colours and body-colour, with pen and black ink, on grey paper; 136 : 188.

Presented by Mr. John Ruskin in 1861.

Date about 1830; engraved on steel, somewhat reduced, by J. B. Allen, for *Turner's Annual Tour — The Loire*, 1833; this was subsequently reprinted several times (see *Rawlinson*, II, p. 260, No. 438). The drawing was No. 27 in the original list of Ruskin's 1861 gift; and is No. 22 in the list given on pp. 599–60 of Vol. XIII of the *Works*. A copy of No. 35 by Alexander Macdonald (1839–1921; appointed first Ruskin Master of Drawing by Ruskin) was in the Ruskin Cabinet at Whitelands College (*Works*, XXX, p. 354, n. 8).

36. (XXVI) *The Bridge and Château at Amboise*.

Water-colours and body-colour, with black, brown and reddish inks, over pencil, on grey paper; 134 : 187.

Presented by Mr. John Ruskin in 1861.

Date about 1830; probably based on the slight pencil sketch in the centre of folio 16a of the *'Loire, Tours, Orleans, and Paris' Sketch Book* (*Inventory*, No. CCXLIX). No. 36 was not engraved, but has been described as 'the first thought' of the preceding drawing (No. 35), which, with its more dramatic composition, was engraved by J. B. Allen. The drawing was No. 14 in the original list of Ruskin's 1861 gift; and is No. 23 in the list given on pp. 559–60 of Vol. XIII of the *Works*.

37. (XLVID) *Angers*.

Water-colours and body-colour, touched with pen and ink, on grey paper; 136 : 187.

Presented by Mr. John Ruskin in 1861.

Date about 1830; there is a very slight pencil sketch of the same view, without the boats or stormy sky, on folio 30 of the *'Nantes, Angers, and Saumur' Sketch Book* (*Inventory*, No. CCXLVIII). No. 37 was not engraved, and there is no view of Angers in *Turner's Annual Tour* of 1833. The drawing was No. 18 in the original list of Ruskin's 1861 gift; and is No. 19 in the list given on pp. 559–60 in Vol. XIII of the *Works*.

38. (XLVIE) *'Amboise'*.

Water-colours and body-colour, touched with the pen, on grey paper; 132 : 187.

Presented by Mr. John Ruskin in 1861.

Date about 1830; engraved on steel (somewhat reduced), with dappled clouds and the rays of the setting sun added in the sky, and some further vessels on the river, by W. R. Smith, for *Turner's Annual Tour — The Loire*, 1833; this was subsequently reprinted several times (see *Rawlinson*, II, p. 260, No. 437). The drawing was No. 26 in the original list of Ruskin's 1861 gift; and is No. 16 in the list given on pp. 559–60 of Vol. XIII of the *Works*.

39. (XLVIF) *'Château Hamelin, between Oudon and Ancenis'*.

Water-colours and body-colour, with pen and reddish-brown ink and some scratching out, on grey paper; 137 : 189.

Presented by Mr. John Ruskin in 1861.

Date about 1830; probably based on the very slight pencil sketches on folios 14 and 14a of the *'Nantes, Angers, and Saumur' Sketch Book* (*Inventory*, No. CCXLVIII). No. 39 was engraved on steel, somewhat reduced and with a flight of gulls added in the sky on R., by R. Brandard, for *Turner's Annual Tour — The Loire*, 1833; this was subsequently reprinted several times (see *Rawlinson*, II, p. 263, No. 448). The drawing was No. 35 in the original list of Ruskin's 1861 gift; and is No. 26 in the list given on pp. 559–60 of Vol. XIII of the *Works*.

In his third letter of March 1861 to Dr. Acland, Ruskin describes No. 39 as 'inferior, owing to a repentir in the left corner' (see above, p. 33).

40. (XLVIɢ) *'Montjen'*.

Water-colours and body-colour, touched with brown and black ink and with some scratching out, on blue-grey paper; 135 : 188.

Presented by Mr. John Ruskin in 1861.

Date about 1830; this drawing is based on the small and very slight pencil sketches on folios 20 and 21 of the *'Nantes, Angers, and Saumur' Sketch Book* (*Inventory*, No. CCXLVIII). No. 40 was engraved, somewhat reduced, as an evening scene with the rising moon and its reflection added on R., by J. T. Willmore, for *Turner's Annual Tour — The Loire*, 1833; this was subsequently reprinted several times (see *Rawlinson*, II, p. 262, No. 445). The drawing was No. 36 in the original list of Ruskin's 1861 gift; and is No. 8 in the list given on pp. 559–60 of Vol. XIII of the *Works*.

In his third letter of March 1861 to Dr. Acland, Ruskin describes No. 40 as one of two drawings in the series (the second is No. 42) which 'are full of repentirs and are entirely bad'; and adds : 'but I sent them with the rest — lest it should be thought that I had kept the two best — many people might think them so. They are instructive, as showing the ruin that comes on the greatest men when they change their minds wantonly' (see above, p. 33). Ruskin's severe criticisms of the present drawing seem to be unjustified, and no 'repentirs' are immediately evident. It may be that his remarks were based on a comparison between the drawing and the much altered and, as a result, more forceful engraving.

41. (XXX) *'Coteaux de Mauves'*.

Water-colours and body-colour, with pen and reddish and black ink and some scratching out, on grey paper; 138 : 187.

Presented by Mr. John Ruskin in 1861.

Date about 1830; this drawing is probably based on a very slight pencil sketch at the top of folio 24a in the *'Nantes, Angers, and Saumur' Sketch Book* (*Inventory*, No. CCXLVIII). It was engraved on steel, somewhat reduced, by R. Wallis, for *Turner's Annual — Tour The Loire*, 1833; this plate was subsequently reprinted several times (see *Rawlinson*, II, p. 264, No. 451). In the engraving more clouds have been added, and also a small white cottage at the foot of the cliff, near the R. margin; this last was drawn in by Turner himself on the third engraver's proof (now in the British Museum; see *Rawlinson, loc. cit.*). The drawing was No. 23 in the original list of Ruskin's 1861 gift; and is No. 15 in the list given on pp. 559–60 of Vol. XIII of the *Works*.

42. (XXXI) *'Blois'*.

Water-colours and body-colour, with pen and brown and black ink, on grey paper; 135 : 183.

Presented by Mr. John Ruskin in 1861.

Date about 1830; engraved on steel, somewhat reduced, by R. Brandard, for *Turner's Annual Tour — The Loire*, 1833; this was subsequently reprinted several times (see *Rawlinson*, II, p. 259, No. 435). The drawing was No. 30 in the original list of Ruskin's 1861 gift; and is No. 9 in the list given on pp. 559–60 of Vol. XIII of the *Works*. Reproduced: L. Herrmann, *J. M. W. Turner*, 1963, pl. 13. Exhibited: Whitechapel Art Gallery, *J. M. W. Turner*, 1953, No. 198.

This is the second of the two Loire drawings about which Ruskin was especially critical in his third letter of March 1861 to Dr. Acland (see above, No. 40, and p. 33). As with No. 40 it is again difficult to see the reasons for Ruskin's severe criticisms, and the drawing certainly does not appear to be 'full of repentirs'.

43. (XLVIH) *'The Canal of the Loire and Cher, near Tours'*.

Water-colours and body-colour, touched with the pen, on grey paper; 123 : 182.

Presented by Mr. John Ruskin in 1861.

Date about 1830; this drawing is probably based on the slight pencil sketch on folio 8 of the *'Loire, Tours, Orleans, and Paris'* Sketch Book (*Inventory*, No. CCXLIX). No. 43 was engraved on steel, somewhat reduced, by T. Jeavons, for *Turner's Annual Tour — The Loire*, 1833; this was subsequently reprinted several times (see *Rawlinson*, II, pp. 260–1, No. 439). The drawing was No. 25 in the original list of Ruskin's 1861 gift; and is No. 10 in the list given on pp. 559–60 of Vol. XIII of the *Works*. Exhibited: Whitechapel Art Gallery, *J. M. W. Turner*, 1953, No. 200.

In his third letter of March 1861 to Dr. Acland, Ruskin wrote of No. 43 that it 'has two repentirs if not more — one in the sun: the other in the flags — but has high qualities here and there' (see above, p. 33).

44. (XXIX) *'Palace at Blois'*.

Pen and black and brown ink, over pencil, with water-colours and body-colour, on grey paper; 130 : 185.

Presented by Mr. John Ruskin in 1861.

Date about 1830; probably based on a slight pencil sketch on folio 20a of

the '*Loire, Tours, Orleans, and Paris' Sketch Book* (*Inventory*, No. CCXLIX). No. 44 was engraved on steel, somewhat reduced, by R. Wallis, for *Turner's Annual Tour — The Loire*, 1833; this was subsequently reprinted several times (see *Rawlinson*, II, p. 259, No. 436). The drawing was No. 31 in the original list of Ruskin's 1861 gift; and is No. 20 in the list given on pp. 559–60 of Vol. XIII of the *Works*. An aquatint after the drawing, etched by Ruskin and engraved by T. Lupton, was one of three new plates added to the 1888 edition of Volume V of *Modern Painters* (see above, p. 40): this illustration was not, however, discussed in that Volume (see *Works*, VII, pl. 85, facing p. 203; and footnote on pp. 203–4, where the references to the plate of the '*Palace at Blois*' are listed). Exhibited: Whitechapel Art Gallery, *J. M. W. Turner*, 1953, No. 201.

45. (XLVIIA) '*St. Julian's, Tours*'.
Pen and black and brown ink, over pencil, with water-colours and body-colour, on grey paper; 120 : 184.
Presented by Mr. John Ruskin in 1861.
Date about 1830; a pencil drawing on folio 45a of the '*Loire, Tours, Orleans, and Paris' Sketch Book* (*Inventory*, No. CCXLIX) records the same scene as the present drawing, but from a different view-point. No. 45 was engraved on steel, somewhat reduced and altered into a night scene, by W. Radclyffe, for *Turner's Annual Tour — The Loire*, 1833; this was subsequently reprinted several times (see *Rawlinson*, II, p. 261, No. 441). The drawing was No. 32 in the original list of Ruskin's 1861 gift; and is No. 1 in the list given on pp. 559–60 of Vol. XIII of the *Works*. Exhibited: Whitechapel Art Gallery, *J. M. W. Turner*, 1953, No. 202.

46. (XXXIII) '*Tours*'.
Water-colours and body-colour over pencil, touched with the pen, on grey paper; 122 : 183.
Presented by Mr. John Ruskin in 1861.
Date about 1830; engraved on steel, somewhat reduced and with the bridge and buildings in the background considerably strengthened, by R. Brandard, for *Turner's Annual Tour — The Loire*, 1833; this plate was subsequently reprinted several times (see *Rawlinson*, II, p. 261, No. 440). The drawing was No. 24 in the original list of Ruskin's 1861 gift; and is No. 2 in the list given on pp. 559–60 of Vol. XIII of the *Works*. Reproduced: Armstrong, *Turner*, 1902, p. 81, pl. 43.

No. 46 was picked out by Ruskin as one of the two best of the Loire drawings which he presented in 1861 (see above, p. 33).

47. (XXXII) *'Beaugency'*.

Water-colours and body-colour, with pen and reddish-brown ink, on grey paper; 118 : 175.

Presented by Mr. John Ruskin in 1861.

Date about 1830; probably based on a very slight pencil sketch on folio 27 of the *'Loire, Tours, Orleans, and Paris' Sketch Book* (*Inventory*, No. CCXLIX). No. 47 was engraved, somewhat reduced, with an effect of morning light and reflections, and with the addition of a second buoy in the centre, by R. Brandard, for *Turner's Annual Tour — The Loire*, 1833; this was subsequently reprinted several times (see *Rawlinson*, II, p. 259, No. 434). The drawing was No. 28 in the original list of Ruskin's 1861 gift; and is No. 13 in the list given on pp. 559–60 of Vol. XIII of the *Works*.

No. 47 was picked out by Ruskin in his third letter of March 1861 to Dr. Acland as one of two drawings 'entirely magnificent in their own quiet way' (see above, p. 33).

48. (XLVIIB) *'Orleans'*.

Water-colours and body-colour, with pen and red, brown and black ink, on grey paper; 136 : 189.

Presented by Mr. John Ruskin in 1861.

Date about 1830; probably based on a slight pencil sketch on folio 34 of the *'Loire, Tours, Orleans, and Paris' Sketch Book* (*Inventory*, No. CCXLIX). No. 48 was engraved on steel, somewhat reduced and with much more definition in the architectural details, by Thomas Higham, for *Turner's Annual Tour — The Loire*, 1833; this was subsequently reprinted several times (see *Rawlinson*, II, pp. 258–9, No. 433). The drawing was No. 33 in the original list of Ruskin's 1861 gift; and is No. 12 in the list given on pp. 559–60 of Vol. XIII of the *Works*.

49. (XXXIV) *'Rietz, near Saumur'*.

Water-colours and body-colour over pencil, with pen and brown ink, on grey paper; 124 : 181.

Presented by Mr. John Ruskin in 1861.

Date about 1830; engraved on steel, somewhat reduced and with the addition of two boats near L. lower corner, by R. Brandard, for *Turner's Annual Tour*

— *The Loire*, 1833; this was subsequently reprinted several times (see *Rawlinson*, II, p. 262, No. 444). The drawing was No. 29 in the original list of Ruskin's 1861 gift; and is No. 11 in the list given on pp. 559–60 of Vol. XIII of the *Works*.

No. 49 is the second of the two drawings picked out by Ruskin in his third letter of March 1861 to Dr. Acland as 'entirely magnificent in their own quiet way' (see above, p. 33). A rough outline etching by Ruskin of the drawing (in reverse) is reproduced as plate 73 of Vol. VII of the *Works*, and was one of the original illustrations in Volume V of *Modern Painters* (1860), in which the composition is discussed at some length as 'one of the simplest subjects, in the series of the Rivers of France' (*loc. cit.*, pp. 217–21).

50. (Colour Plate C) *'Scene on the Loire' (near the Coteaux de Mauves)*.
Water-colours and body-colour, touched with pen and black ink, on grey paper; 140 : 190.
Presented by Mr. John Ruskin in 1861.
Date about 1830; perhaps based on a slight pencil sketch on folio 22a of the *'Nantes, Angers, and Saumur' Sketch Book* (*Inventory*, No. CCXLVIII). It was engraved on steel, somewhat reduced and with the distance rather more defined, by R. Wallis, for *Turner's Annual Tour — The Loire*, 1833; this plate was subsequently reprinted several times (see *Rawlinson*, II, p. 263, No. 449). This *Scene on the Loire* was No. 21 in the original list of Ruskin's 1861 gift; and is No. 14 in the list given on pp. 559–60 of Vol. XIII of the *Works*. Reproduced : Rothenstein and Butlin, *Turner*, 1964, pl. 69b.

In his third letter of March 1861 to Dr. Acland, Ruskin describes No. 50 as 'the best of the Loire series' and 'priceless' (see above, p. 33). In the *General Index* volume of the *Works* (XXXIX, p. 629) there is a confusion between the present drawing and the other *Scene on the Loire* (No. 82 below; Ruskin School Standard Series, No. 3); it is the plate after No. 50, and *not* the latter which is referred to on pp. 547–8 of Vol. III of the *Works*.

51. (XLVIIc) *'Château de Nantes'*.
Water-colours and body-colour, touched with pen and brown and black ink, on blue-grey paper; 123 : 180.
Presented by Mr. John Ruskin in 1861.
Date about 1830; engraved on steel, somewhat reduced and with clouds added, by W. Miller, for *Turner's Annual Tour — The Loire*, 1833; this plate was subsequently reprinted several times (see *Rawlinson*, II, p. 264, No. 452).

The drawing was No. 34 in the original list of Ruskin's gift; and is No. 27 in the list given on pp. 559–60 of Vol. XIII of the *Works*. A copy of No. 51 by Alexander Macdonald was in the Ruskin Cabinet at Whitelands College (*Works*, XXX, p. 354, No. 50 and note I).

There are two views of the promenade at Nantes among the *Rivers of France* water-colours in the Turner Bequest (*Inventory*, No. CCLIX, Nos. 191 and 200), but neither is directly connected with the present drawing. Both the Turner Bequest drawings were included in the 1857–8 Exhibition of *Sketches and Drawings by J. M. W. Turner, R.A.* at Marlborough House. In his Catalogue notes Ruskin wrote of CCLIX, No. 200, in relation to the present drawing: 'the Nantes is far prettier [than the engraved drawing], being an idea of a finer day. The engraved drawing is of a bleak grey afternoon, and taken from the end of the walk, where the colossal statues become principal objects, and they are not interesting ones.' (*Works*, XIII, pp. 311–12.)

52. (XXXVII) *'Santa Maria della Spina, Pisa' (Vignette).*

Water-colours, on buff paper; 190 :173 (the paper has darkened considerably).

Presented by Mr. John Ruskin in 1861.

Date about 1832; based on a sketch by W. Page, and engraved on steel, considerably reduced, by E. Finden for Vol. I of *Byron's Life and Works*, published by John Murray in 1832–4 (*Rawlinson*, II, p. 251, No. 415). The engraving is dated 1st May 1832. This vignette is described as being based on the sketch of another artist; however, Turner himself visited Pisa, and the pencil drawing on folio 55 of the *Genoa and Florence Sketch Book* (*Inventory*, No. CCXXXIII), which was used in 1828, shows the same view of the Chapel and its surroundings, though it does not include the boats. The present drawing was No. 10 in the original list of Ruskin's 1861 gift; and is No. 28 in the list given on pp. 559–60 of Vol. XIII of the *Works*. Ruskin paid 50 guineas for it (see above, p. 34). A copy of No. 52 by Alexander Macdonald was in the Ruskin Cabinet at Whitelands College (*Works*, XXX, p. 355, note 1).

In his *Notes* to the 1878 Exhibition of his drawings by Turner, which included two of the Byron vignettes, Ruskin wrote: 'The illustrations to Scott and Byron were much more laboured [than those for Rogers' *Italy*], and are more or less artificial and unequal. I have never been able to possess myself of any of the finest; the best I had, Ashestiel, was given to Cambridge' (*Works*, XIII, p. 445).

53. (XLVIID) *'The School of Homer, Scio' (Vignette)*.

Water-colours, touched with the pen, on buff paper; 210 : 200 (the paper has darkened considerably).

Presented by Mr. John Ruskin in 1861.

Date about 1833; based on a sketch by W. Page, and engraved on steel, considerably reduced, by E. Finden for Vol. XVII of *Byron's Life and Works*, published by John Murray in 1832–4 (*Rawlinson*, II, p. 255, No. 430). The engraving is dated 1833. The drawing was No. 11 in the original list of Ruskin's 1861 gift; and is No. 32 in the list given on pp. 559–60 of Vol. XIII of the *Works*. Ruskin paid 50 guineas for it (see above, p. 34, and also note to the preceding drawing).

54. (XXXV) *'Mount Lebanon and the Convent of St. Antonio'*.

Water-colours over slight pencil indications, touched with pen and ink; 146 : 200.

Presented by Mr. John Ruskin in 1861.

Date about 1835; drawn from a sketch by C. Barry, and engraved on steel, somewhat reduced, by W. Finden as plate 19 of Vol. I of *The Biblical Keepsake, or Landscape Illustrations of the most remarkable Places mentioned in The Holy Scriptures*, published by John Murray in 1835 (*Rawlinson*, II, p. 308, No. 584). Turner never visited the Middle East or Greece and his Bible illustrations were all based on sketches taken on the spot by various amateur and professional artists. A complete series of his tracings of these sketches was in the possession of Mr. C. Mallord Turner. The present drawing was No. 1 in the original list of Ruskin's 1861 gift; and is No. 34 in the list given on pp. 559–60 of Vol. XIII of the *Works*. Exhibited : Arts Council Gallery, *Ruskin and his Circle*, 1964, No. 100.

In his third letter of March 1861 to Dr. Acland, Ruskin included this and the following drawing in the list of 'entirely first-raters', and said that he had paid ninety guineas for each (see above, p. 33).

Ruskin made a number of references to Turner's Bible drawings, the earliest of which is in the first volume of *Modern Painters*. In Chapter III of Section IV of Part II, entitled *Of the Inferior Mountains*, paragraph 7 is devoted to the *Mount Lebanon*. In the discussion of Turner's drawing of 'inferior mountains', this is singled out as 'perhaps the finest instance, or at least the most marked of all. . . . There is not one shade nor touch on the rock which is not indicative of the lines of stratification; and every feature is marked with a straight-forward simplicity which makes you feel that the artist has nothing in his

heart but a keen love of the pure unmodified truth . . . the rocks are laid one above another with unhesitating decision; every shade is understood in a moment. . . .' (*Works*, III, p. 454). In Volume V of *Modern Painters* Ruskin used information given to him in a letter from his friend, the Rev. William Kingsley, when he wrote that Turner 'took the Sinai and Lebanon to show the opposite influences of the Law and the Gospel' (Part VII, Chap. IV, Para. 21; *Works*, VII, pp. 191–2). This is one of the very rare occasions on which Turner's own explanation of the meaning of his work is recorded.

Ruskin owned altogether six of Turner's drawings for Finden's Bible; the present example, the following drawing of '*Jericho*', '*Pools of Solomon*', which he presented to Cambridge, *Jerusalem — The Pool of Bethesda, Rhodes* and *Corinth*. In his note to the last in the catalogue of the 1878 Exhibition (*Works*, XIII, p. 447), Ruskin wrote: 'This and the next following belong to the series of illustrations of Palestine [*sic*], to which Turner gave his utmost strength, as far as he knew himself at this time in what his strength lay. He had never been in Palestine . . . and the drawings have grave faults, but are quite unrivalled examples of his richest executive power on a small scale. My three best were given to Cambridge and Oxford, but these that I have left are not unworthy.'

55. (XLVG) '*Jericho*'.

Water-colours over pencil, touched with the pen and with some scratching out; 122 : 198.

Collections: J. F. Lewis; Ruskin.

Presented by Mr. John Ruskin in 1861.

Date about 1835; drawn from a sketch by the Rev. R. Masters, and engraved on steel, somewhat reduced and with slight variations, by W. Finden as plate 4 of Vol. II of *The Biblical Keepsake, or Landscape Illustrations of the most remarkable Places mentioned in The Holy Scriptures*, published by John Murray in 1835 (*Rawlinson*, II, p. 305, No. 576). The present drawing was No. 2 in the original list of Ruskin's 1861 gift; and is No. 33 in the list given on pp. 559–60 of Vol. XIII of the *Works*. Exhibited: Art Council Gallery, *Ruskin and his Circle*, 1964, No. 110. See also note to the preceding drawing (No. 54).

Copies in oils of the '*Jericho*' and of the '*Pools of Solomon*', then belonging to Major A. H. White, were seen at the British Museum by Mr. E. Croft-Murray in 1948. These were very probably the work of J. F. Lewis, R.A., whose name was inscribed on the back of each. They were accompanied by a series of letters written by Ruskin to Lewis in 1858 and 1859, which indicate

that in the former year Ruskin exchanged the *'Jericho'* for two of Lewis' own sketches, and bought it back in the latter year. For further details of this correspondence see pp. 29–30 above.

56. (XXXVIII) *Venice: the Grand Canal.*

Water-colours over slight pencil indications, with pen and red and blue ink, and some heightening with white; 215 : 315 (the paper has darkened considerably, resulting in an overall yellowish tone).

Presented by Mr. John Ruskin in 1861.

Date 1840; on the R. is S. Maria della Salute, and beyond, nearer the centre, the Dogana. The drawing was No. 6 in the original list of Ruskin's 1861 gift; and is No. 31 in the list given on pp. 559–60 of Vol. XIII of the *Works*. In the original list this and the two following Venetian drawings were described as 'Sketch on the spot': in his third letter of March 1861 to Dr. Acland (see p. 33) Ruskin listed all three as 'entirely first-raters', and recorded that he paid fifty-five guineas for each. The three drawings are listed on p. 162 of Finberg's *In Venice with Turner*, 1930, in which the present drawing is reproduced on plate XXIX. Exhibited: Whitechapel Art Gallery, *J. M. W. Turner*, 1953, No. 214.

The dating of Turner's later Venetian drawings is extremely difficult, and much research remains to be done before any finality can be achieved. Finberg's conclusions (*loc. cit.*) have been disputed by C. F. Bell, whose notes on the subject are deposited in the Print Room at the British Museum, and also in the Library of the Victoria and Albert Museum. Finberg was almost certainly mistaken in assigning No. 56, and the two following drawings, to 1844, a somewhat arbitrary date, as Turner's last visit to Venice was in 1840. His judgement of these drawings was, in fact, unjustifiably harsh when he wrote that 'they show that Turner's skill of hand and his marvellous sense of colour had almost deserted him; not only is the execution feeble, and the colour muddled, but the mental or imaginative driving force behind them seems to be exhausted' (*loc. cit.*, p. 152). Both in colour and composition the three drawings are entirely deft and convincing, and they were probably made on the spot, as suggested by Ruskin. While rather more positive in colour and line, Nos. 56–8 are comparable to the water-colour sketches in the *Roll Sketch Book of Venice* in the Turner Bequest (*Inventory*, No. CCCXV), which Finberg in 1930 dated to 1840, suggesting that 'the pencil outlines only — generally very slight and summary — were done from nature; the colouring was done afterwards from memory' (*loc. cit.*, p. 171). The Ash-

molean drawings are almost identical in size to the sheets of the Venetian *Roll Sketch Book,* the discrepancies being due to trimming; if they were not at one time part of it, then certainly they derive from a very similar sketch-book.

Finberg considered the present drawing 'an unsuccessful attempt to elaborate the brilliant sketch' which is No. 6 in the *Roll Sketch Book of Venice* (*Inventory,* p. 1016; reproduced, Finberg, *loc. cit.,* pl. XXIIa), but, in fact, the view-point differs very considerably. The view most like it in the various Venetian sketch-books in the Turner Bequest is that on folio 75a of the *Venice Sketch Book* (*Inventory,* No. CCCXIV), which was thought by Finberg to have been used in 1835, but considered by Bell to date from 1832 — a year he proposed for a previously unrecorded visit by Turner to Venice.

57. (Colour Plate D) *Venice: the Accademia.*
Water-colours over slight pencil indications, with pen and red and black ink, and some scraping out; 217 : 318 (the paper has darkened slightly).
Presented by Mr. John Ruskin in 1861.
Date 1840; on L. the Rio Terra Antonio Foscarini, with the former Chiesa della Carità adjoining it on R. and the main building of the Accademia standing back in centre. The drawing was No. 7 in the original list of Ruskin's 1861 gift; and is No. 30 in the list given on pp. 559–60 of Vol. XIII of the *Works.* For Ruskin's estimation of it, and for a discussion of the problem of its dating, see the note to the preceding drawing (No. 56). Reproduced: Armstrong, *Turner,* 1902, pl. 66, facing p. 124.

In his *Guide to the Principal Pictures in the Academy of Fine Arts at Venice,* published in Venice in 1877, Ruskin described the exterior of the Academy, 'which,' he wrote, 'if any of my readers care for either Turner or me, they should look at with some moments' pause; for I have given Turner's lovely sketch of it to Oxford, painted as he saw it fifty years ago, with bright golden sails grouped in front of it where now is the ghastly iron bridge' (built in 1854, and replaced by the present provisional wooden bridge in 1932; *Works,* XXIV, p. 172).

58. (XXXIX) *Venice: the Riva degli Schiavoni.*
Water-colours, with pen and red and brown ink and some scraping out; 217 : 318 (the paper has darkened, resulting in an overall yellowish tone).
Presented by Mr. John Ruskin in 1861.
Date 1840; view from a boat on the Bacino di S. Marco, with the Campanile

on L., the church of S. Maria della Pietà on R. and S. Zaccaria and its campanile in centre. The drawing was No. 8 in the original list of Ruskin's 1861 gift; and is No. 29 in the list given on pp. 559–60 of Vol. XIII of the *Works*. For Ruskin's estimation of it and for a discussion of the problem of its dating, see the note to No. 56 above. Reproduced: Finberg, *In Venice with Turner*, 1930, pl. XXIXb.

Drawings in the
Ruskin School Collection

59. (II) *Boats on a Beach.*

Water-colours over pencil; 131 : 216 (the drawing has been torn from lower L. to upper R., where there is a repaired hole).

Ruskin School Collection (Rudimentary Series, No. 126; *Works*, XXI, p. 206).

Date about 1793. This drawing should be compared with the series of scenes in or near Dover Harbour, about which there is still considerable confusion, despite various publications devoted to them (see A. J. Finberg, 'Some So-called Turners in the Print Room', in *The Burlington Magazine*, IX (1906), pp. 191–5; E. Croft-Murray, 'Pencil Outlines of Shipping at Dover of the "Monro School"', in *The British Museum Quarterly*, X (1935–6), pp. 49–52). This discussion has been centred round four drawings bequeathed to the British Museum by John Henderson, Esq., in 1878 (Binyon, *Catalogue of Drawings by British Artists . . . in the British Museum*, IV (1907), p. 211, Nos. 7–10). Only one of these (*loc. cit.*, No. 7) is considered to be by Turner himself, though after John Henderson, Senior, while the others are thought to be the work of that amateur artist. The present drawing is of the same relatively high quality as Binyon's No. 7, and may with confidence be given to Turner himself. The dating of No. 59 depends on the series of early 'Dover Subjects' in the Turner Bequest (*Inventory*, No. XVI), for no Henderson 'prototype' for it has been located.

Ruskin thought very highly of this drawing, describing it in his *Catalogue of the Rudimentary Series* (*loc. cit.*) as 'Study, of consummate excellence, in Turner's early manner.' Exhibited: Fine Art Society, 1878, No. 6 (*Works*, XIII, p. 416). Ruskin's note in that catalogue reads: 'Utmost delicacy, with utmost decision. Take a lens to it, you will find the teeth of the saw in the carpenter's hand, and the blocks of the shrouds, in the distant vessels. Yet the gradation of the interior of the boat is given with one dash of colour, carefully managed while wet, and the harmony of the whole is perfect. The sky is

singularly tender and lovely.' The 1878 catalogue (Vol. XIII, p. 533) also includes a note on No. 59 by the Rev. W. Kingsley, who copied the drawing nineteen times.

60. (III) *The Ruined Abbey at Haddington.*
 Water-colours over pencil; 175 : 203.
 Ruskin School Collection (Educational Series, No. 102; *Works*, XXI, pp. 84 and 128).

 Dating from about 1793 to 1795, this unfinished drawing is copied from an engraving by W. Byrne after Thomas Hearne, dated 25 March 1786, in Vol. I of the *Antiquities of Great Britain*. The engraving, for which the drawing was made in 1778, shows the river, bridge and town on R. Turner's first visit to Haddington was made in 1801 (*Finberg, Life*, p. 73); the style of No. 60 rules out any possibility of its being executed during or after that visit.

 The drawing was described by Ruskin simply as *Ruined Abbey*, and was identified as Haddington, East Lothian, by Cook and Wedderburn, who did not realise that it was a copy. In his catalogue note on No. 60 (*loc. cit.*, p. 128) Ruskin, who was also unaware that this was a copy, wrote, 'This I put . . . to be a witness to you, once for all, of the right way to work: — doing nothing without clearly formed intention, nothing in a hurry, nothing more wrong than you can help; all as tenderly as you can, all as instantly as you can, all thoughtfully, and nothing mechanically. Take those laws for absolute ones, in art and life. The drawing is of Turner's early time. . . . You will find that Turner's touches were, for many a day, scholarly, before they were masterly, and so must yours be.'

 Exhibited: Fine Art Society, 1878, No. 5 (*Works*, XIII, pp. 415–6). Ruskin's note in that catalogue reads : 'There are many drawings of this class in the National Gallery; few out of it; and of those few, it would be difficult to find one more perfectly demonstrative of the method of Turner's work. I can never get the public to believe, nor, until they believe it, can they ever understand, the grasp of a great master's mind, that, as in fresco, so in water-colour, there can be no retouching after your day's work is done; if you know what you want, you can do it at once, *then*; and if you don't, you cannot do it at all. There is absolute demonstration in this and at least fifty other such unfinished pieces in the National Gallery, that Turner did his work bit by bit, finishing at once, and sure of his final harmony. When a given colour was needed over the whole picture, he would, of course, lay it over all at once and then go on with detail, over that, as he does here over white paper. I gave the

drawing to the University Schools to be used in examination, a copy of it being required as a test of skill.'

61. (XLIIA) *Old Shops in Chester.*
 Pencil; 276 : 215 (irregular).
 Ruskin School Collection (Educational Series, No. 131; *Works*, XXI, p. 87).
 Drawn in 1794, like the following, on Turner's first visit to Chester (see *Finberg, Life*, p. 25) and very similar in technique to some of the detailed drawings in the '*Matlock*' *Sketch Book* (*Inventory*, No. XIX), used on his Midlands tour that year. The style of the drawings of the '*Chester*' *Sketch Book* (*Inventory*, No. LXXXII, and there dated about 1801–5) is much slighter and more rapid.
 Cook and Wedderburn (*Works*, XXI, p. 87) confuse the present drawing with a third Chester drawing, then in Ruskin's collection, exhibited as No. 78 at the Fine Art Society's Galleries in 1878.

62. (XLIIC) *Old Houses in Chester.*
 Pencil; 261 : 209.
 Ruskin School Collection (Educational Series, No. 132; *Works*, XXI, p. 87).
 Date 1794; see note to preceding drawing (No. 61). Exhibited : Fine Art Society, 1878, No. 79 (*Works*, XIII, p. 463).

63. (XLIIIB) *Bergamo.*
 Water-colours, over slight pencil indications; 162 : 224.
 Ruskin School Collection (Rudimentary Series, No. 127; *Works*, XXI, p. 207).
 Dating from about 1795, and thus belonging to a period considerably before Turner's first visit to Italy, this drawing must have been copied from a print or drawing, possibly by J. R. Cozens, though, according to C. F. Bell, that artist did not visit Bergamo. No. 63 closely resembles in mood, colouring and composition (reversed) a water-colour, *Windmill on Hill*, in the Turner Bequest (*Inventory*, No. XXVII, I, and there dated about 1795). Exhibited : Fine Art Society, 1878, No. 4 (*Works*, XIII, p. 415), and referred to by Ruskin in his *Notes* at some length: 'This wonderful little drawing is the earliest example I can give of the great distinctive passion of Turner's nature; ... This little drawing was evidently made before he had ever been abroad. It is an endeavour to realise his impressions of Italy, from some other person's sketch : the Alps, with the outline of Sussex downs, and the small square-built

Bergamo, enough show this; but the solemnity of feeling in the colour and simple design of it, as in the prominence of the shrine on the hill against the sky, are unfound in any of his later works. . . .'

64. (VI) *Mountain Landscape with a Bridge.*
Grey and blue washes over pencil; 247 : 380.
Ruskin School Collection (Reference Series, No. 150; *Works*, XXI, p. 41, 'Drawing in neutral tint by Turner').
This dates from the mid-1790s, and clearly belongs to the considerable group of drawings executed by Turner, Girtin and others under the auspices of Dr. Monro (*Finberg, Life*, pp. 35–40; *Bell and Girtin*, pp. 20–3). The Turner Bequest includes numerous drawings of this character, formerly in Dr. Monro's collection (*Inventory*, Nos. CCCLXXIII–V etc.); a positive attribution for any of them is difficult to establish. See also the note to No. 95 below.

65. (IV) *Durham Castle from across the River.*
Pencil; 366 : 263.
Ruskin School Collection (Educational Series, No. 126; *Works*, XXI, p. 86).
Date 1797. This drawing probably belonged to the '*Tweed and Lakes*' *Sketch Book* (*Inventory*, No. XXXV), which contains several views of Durham. Although Finberg (*Inventory*, p. 123) believed No. 65 to have belonged to the '*Smaller Fonthill*' *Sketch Book*, as did the five following drawings, it is far closer, both in style and in size of the sheet, to the former, slightly earlier sketch-book.

66. (XLIID) *Coast of Yorkshire, near Whitby.*
Pencil; 263 : 410.
Ruskin School Collection (Educational Series, No. 141; *Works*, XXI, p. 87).
Date 1801; according to Finberg this and the four following drawings originally belonged to the '*Smaller Fonthill*' *Sketch Book* (*Inventory*, No. XLVIII), which was in use from 1799 to 1802. All these rapid drawings were executed during the North of England and Scottish tour, which Turner made in 1801 (*Finberg, Life*, p. 73). No. 66 was the basis of a considerably later and somewhat smaller pen and sepia drawing (*Inventory*, No. CXVII, B), which in its turn served as the model for the plate of the same title in the *Liber Studiorum* (*Rawlinson, Liber*, p. 63, No. 24). A copy of this plate, which was etched by Turner and engraved by W. Say (published 1st January 1811), followed

the present drawing as the next number in the Educational Series. In the later drawing, as in the plate, the hasty pencil notation of No. 66 was transformed into a dramatic episode; the small figures became survivors from a shipwreck, surrounded by angry seas, threatening sky and much local incident.

67. (XLIIF) *Solway Moss.*
 Pencil, with some grey wash; 255 : 413.
 Ruskin School Collection (Educational Series, No. 143; *Works*, XXI, p. 87).
 Date 1801; from the *'Smaller Fonthill' Sketch Book* (see note to No. 66 above). Two even slighter pencil sketches of Solway Moss are included in the *Scotch Lakes Sketch Book* (*Inventory*, No. LVI, fols. 179a–181). The succeeding item to No. 67 in the Educational Series was the *Solway Moss* plate from the *Liber Studiorum* (*Rawlinson, Liber*, p. 125, No. 52), which was published on 1st January 1816, etched by Turner and engraved by T. Lupton. The present drawing differs considerably in composition from the finished plate, but its use as a prototype is clearly seen when it is compared with a copy of the etching touched by Turner, bequeathed to the British Museum by Mr. Henry Vaughan. The topographical inaccuracy of the title of both drawing and plate has been fully discussed by Rawlinson (*loc. cit.*).

68. (XLIIG) *Sketch of Clouds and Hills at Inverary.*
 Pencil, with some grey wash; 260 : 411.
 Ruskin School Collection (Educational Series, No. 292; *Works*, XXI, p. 101).
 Date 1801; from the *'Smaller Fonthill' Sketch Book* (see note to No. 66 above).

69. (XLIII) *Scarborough.*
 Water-colours over pencil; 258 : 411.
 Ruskin School Collection (Rudimentary Series, No. 128; *Works*, XXI, p. 207).
 Date 1801; from the *'Smaller Fonthill' Sketch Book* (see note to No. 66 above). Turner visited Scarborough on his way North in the summer of 1801 (*Finberg, Life*, p. 73). Exhibited: Fine Art Society, 1878, No. 81 (*Works*, XIII, pp. 463–4). In his Exhibition note Ruskin wrote: 'Observe the perfect, quiet, fearless decision, with no hurry, and no showing off, perspective watched in every line, then the perfect setting of the beds of the rock up the angle of it, when they are vital to it, up to the highest piece of Castle. . . .'

70. (XLIIE) *Dunblane Cathedral.*
 Pencil; 261 : 404.
 Ruskin School Collection (Educational Series, No. 145; *Works*, XXI, p. 88).
 Date 1801; from the *'Smaller Fonthill' Sketch Book* (see note to No. 66 above.) The *Scotch Lakes Sketch Book* (*Inventory*, No. LVI), also dating from the tour of 1801, includes, on folios 145a and 146, a smaller and even more rapid pencil sketch of the same scene. Both these drawings show every sign of having been done on the spot, and one or both of them must have served as the basis of the much more elaborate and considerably later pen and sepia drawing listed among the *Liber Studiorum* drawings (*Inventory*, No. CXVIII, C). In this, as in the resultant *Liber Studiorum* plate, the subject has been considerably cut at the L. and top margins, so that much less of the ruin is shown, while there is considerably more detail in the foreground. The plate (*Rawlinson, Liber*, p. 135, No. 56), etched by Turner and engraved by T. Lupton, was published on 1st January 1816.
 Ruskin, in the first of his *Lectures on Landscape*, delivered in Oxford in Lent Term, 1871, referred to No. 70 as follows: 'the sketch from Nature of Dunblane Abbey for the *Liber Studiorum*, which shows you what he took from Nature, when he had time only to get what was most precious to him' (*Works*, XXII, p. 26).
 Dr. Kurt F. Pantzer, of Indianapolis, has a pen and sepia sketch corresponding to plate 56. Another pencil drawing of the Cathedral, also apparently extracted from the *'Smaller Fonthill' Sketch Book*, was presented to Dunblane Cathedral in 1963.

71. (XIII) *Study of a Group of Cows.*
 Water-colours over pencil, with some scratching out; 216 : 324.
 Ruskin School Collection (Educational Series, No. 185; *Works*, XXI, pp. 91 and 136).
 Date about 1801; described by Ruskin (*loc. cit.*, p. 136) as 'quite insuperable in perfection of rapid sketching', it is reminiscent of the studies of cattle in the *Cows Sketch Book* (*Inventory*, No. LXII), in which the cow on folio 6 closely resembles that in the foreground of the present drawing.

72. (XV) *Distant View of Lowther Castle (Park Scene).*
 Water-colours and pencil; 224 : 352.
 Collections: Rev. W. Kingsley; Ruskin.
 Ruskin School Collection (Educational Series, No. 128; *Works*, XXI, p. 86).

Date 1809. This and the following two drawings, which were all presented to Ruskin by the Rev. W. Kingsley (*Works*, XIII, p. 533, n. 3), were executed during Turner's visit to Lowther in the summer of 1809. He had been invited there by the Earl of Lonsdale after the success of his two views of Tabley House painted for Sir John Leicester and exhibited at the Royal Academy in 1809. As a result of his visit Turner completed two paintings of Lowther, which were exhibited at the R.A. in 1810 (Nos. 85 and 115). Both show distant views of the castle, but neither is closely related to any of these drawings. *Lowther Castle . . . : Evening* (R.A., No. 85), however, features a detailed study of a thistle in the foreground. No other drawings of Lowther are recorded, though a very rapid sketch in the so-called *Lowther Sketch Book* (*Inventory*, No. CXIII, folio 15) is tentatively identified by Finberg as Lowther. Exhibited: *English Drawings and Water Colors from British Collections*, Washington and New York, 1962, No. 84.

Ruskin referred to No. 72 and also to the following view of Lowther in the first of his 1870 *Lectures on Landscape* (*Works*, XXII, pp. 25–6).

Lowther Castle, Westmorland (about five miles south of Penrith), was built between 1806 and 1811 for William, First Earl of Lonsdale (see H. M. Colvin, *A Biographical Dictionary of English Architects*, 1954, p. 546).

73. (XLVA) *Distant View of Lowther Castle (Park Scene)*.
Pencil; 213 : 356.
Collections: Rev. W. Kingsley; Ruskin.
Ruskin School Collection (Educational Series, No. 127; *Works*, XXI, pp. 86 and 289, n. 2).
Date 1809; the view is similar to that in the preceding drawing (No. 72), but drawn from a point more to the S.W. See the note to that drawing for further details.

74. (XLVB) *Lowther Castle*.
Pencil; 219 : 352.
Collections: Rev. W. Kingsley; Ruskin.
Ruskin School Collection (Rudimentary Series, No. 131; *Works*, XXI, p. 208).
Date 1809; see note to No. 72 above for further details.

75. (XVI) *Study of Trees.*

Pen and sepia ink, with sepia and brownish washes and point of the brush, over pencil; 226 : 336.

Ruskin School Collection (Rudimentary Series, No. 300; *Works*, XXI, pp. 234, 248, 259 and 298, as No. 299, facing which page is a reproduction of a rather unsuccessful 'mezzotint' facsimile by G. Allen (pl. LXVIII)).

Date about 1810–15. Among the *Liber Studiorum* drawings in the Turner Bequest there are many that can be compared in style and technique with No. 75, most notably *Inventory*, Nos. CXVI, P; CXVII, A, J, & N; and CXVIII, E. The last of these is the drawing for the so-called *Raglan Castle* (*Rawlinson, Liber*, p. 140, No. 58), a subject which Turner himself called 'Berry Pomeroy Castle'. It is possible that No. 75, of which there is a replica in the collection of Mrs. F. L. Evans, is a different view of the same place.

In his 1878 *Catalogue of the Rudimentary Series* (*Works*, XXI, p. 298) Ruskin corrected the false statement that No. 75 was a 'sketch for an unpublished Plate of *Liber Studiorum*' which he had made in the earlier 1872 *Catalogue* (*ibid.*, p. 234). He 'prized this drawing' as one of his 'very chief Turner treasures' (*loc. cit.*, p. 298).

76. (Colour Plate B) *Sunshine on the Tamar.*

Water-colours, with some scratching out and use of the brush handle; 217 : 367.

Ruskin School Collection (Reference Series, No. 168; *Works*, XXI, p. 43).

Date about 1813. A preliminary pencil sketch of the composition is on folio 53a of the *Vale of Heathfield Sketch Book* (*Inventory*, No. CXXXVII), which was probably used by Turner on his second tour in Devonshire in the summer of 1813 (*Finberg, Life*, pp. 197–203). Ruskin's earlier title for this drawing was *Pigs in Sunshine. Scene on the Tavey, Devonshire*, and whether the river depicted is the Tamar or the Tavey has not been established. The drawing was previously placed elsewhere in the Ruskin School Collection (see *Works*, XXI, p. 91, n. 6, and pp. 169–70, n. 3), and in a note in the first four editions of the *Catalogue of Rudimentary Series*, in which Ruskin listed it with six of his other Turner drawings 'of very great interest', he wrote (*loc. cit.*, p. 169) : 'It will not, I hope, be attributed to ostentation if I state what I think should be known as an indication of the real quality of the drawings, that Ref. 2 [our No. 79] cost me 500 guineas and Edu. 140 [the present drawing], small as it is, 650.' Ruskin withdrew this drawing before the Ruskin Trust Deed of 1875 was drawn up. It was exhibited at the Fine Art Society in 1878 as No. 31 (*Works*,

XIII, pp. 433–5), and in that catalogue Ruskin referred to it as follows: 'it shows already one of Turner's specially English (in the humiliating sense) points of character — that, like Bewick, he could draw *pigs* better than any other animal. There is also some trace already of Turner's constant feeling afterwards. Sunshine, and rivers, and sweet hills; yes, and who is there to see or care for them? — Only the pigs.'

In 1886, while Ruskin was making efforts to retrieve many of the works he had deposited in, but not actually given to, the Ruskin School (see above, p. 42), he responded to Alexander Macdonald's enquiry about *Sunshine on the Tamar* by finally presenting the drawing. In the letter telling Macdonald of this decision, he wrote: 'I've just ordered the Pigs by Sunlight to be packed for the School — the University has a pretty taste in pigs — I wonder if they'll like Turner's (when they look at them!) better than they did Bewick's.' (A copy of this letter is in the Ruskin School archives.)

A chromo-lithograph of No. 76, engraved by J. Coventry, was published by Gambart in 1855 (*Rawlinson*, II, p. 415, No. 851). Finberg (*Life*, p. 489) suggests that No. 76 may be identical with the water-colour *River Tavey*, included in the exhibition staged in 1829 at the Egyptian Hall, Piccadilly, by Turner's publishers. It was exhibited at the Whitechapel Art Gallery, *J. M. W. Turner*, 1953, No. 147.

77. (XVII) *A Frontispiece (at Farnley Hall)*.

Water-colours over pencil, with pen and ink and some scratching out; 178 : 242 (the L. half of the drawing has been considerably damaged, and there are lesser damages on the R.).

Signed and dated in ink at lower R.: *J. M. W. Turner RA 1815*.

Collections: Walter Fawkes; Stokes; Ruskin.

Ruskin School Collection (Rudimentary Series, No. 14; *Works*, XXI, pp. 174–5).

Dated 1815; drawn at Farnley Hall (which is seen in the background) as the frontispiece to a set of drawings illustrating a collection of Fairfax relics which belonged to Mr. Walter Fawkes. The 'Fairfaxiana' volume is still at Farnley (see A. J. Finberg, *Turner's Water-Colours at Farnley Hall*, n.d., p. 28). The note about No. 77 in the *List of Works by Turner at any Time in the Collection of Ruskin* (*Works*, XIII, p. 600) states that 'Ruskin obtained this drawing, in exchange for some *Liber* proofs, from Mr. Stokes, of Gray's Inn, who had bought it of Colnaghi. In a memorandum sent to Ruskin, Mr. Stokes says that Turner identified the drawing for him. "Fairfaxiana", said the artist, "are

a set of drawings I made for Mr. Fawkes of subjects relating to the Fairfax property which came into Mr. Fawkes' family, and I did this for the frontispiece. The helmet, drinking-cup, and sword were those of a knight of that family who was called Black Jack. The *Illustrated London News* [founded in 1842] got hold of it, and copied the helmet and sword." '

In his 1878 note to the present drawing in the *Catalogue of Rudimentary Series* (*Works*, XXI, pp. 174–5) Ruskin wrote, 'Examine with lens the beautifully legible signature of Oliver Cromwell on the smallest of the fallen papers; also under the helmet the writing of the pedigree of the Farnley family. As brush-work, the sentence "they are sometimes", and the perfectly free "Hawkesworth" and "Richmond" will give a general idea of the ease of Turner's hand in minute lines. The colour of the shields on the principal scroll, and the lion rampant on the standard of Fairfax are to be copied by all students as soon as they have attained some facility in water-colour. The lion being executed with a wash of grey over the underlying vermilion bars, and the roughnesses given by only one process of retouching, with a scratch or two of the knife to conquer the vermilion, is of extremist value as a water-colour exercise. The drawing once belonged to Mr. Fawkes of Farnley, and had been frightfully injured by ill-usage on the left-hand side of it before it came into my possession.' In the *Instructions in Use of Rudimentary Series* Ruskin picks out the present drawing as a 'faultless' example of 'pure water-colour, to be laid so wet that it will run' (*Works*, XXI, p. 248).

78. (XLVc) *Sketch of Pheasant.*
 Water-colours over indications in pencil; 223 : 345.
 Collections : (?)Fawkes; Ruskin.
 Ruskin School Collection (Educational Series, No. 183; *Works*, XXI, p. 91).
 Date about 1815; very probably drawn at Farnley Hall, and perhaps at one time part of the collection of water-colour studies of birds and of the heads of birds (mostly game birds) which Turner drew for Walter Fawkes, the majority of which are still in the family's possession (see A. J. Finberg, *Turner's Water-Colours at Farnley Hall*, n.d., p. 27). Ruskin paid two visits to Farnley Hall, in 1851 and 1884; on the first occasion he was warmly welcomed by Hawksworth Fawkes, the son of Walter, who also knew Turner well. In a letter dated 8th February 1852, in which he commiserated with Hawksworth Fawkes on the recent death of Turner, Ruskin wrote : 'Have you done anything to the drawings of birds yet? I am terrified lest any harm happen to them in framing. Pray tell me they are safe. . . .' (*Works*, XII, p. lvii). Ruskin may

have been given the present drawing by Mr. Fawkes, but this is not at all certain, especially as he also owned several other bird studies, including two of dead pheasants, one slight and the other finished, which were included as lots 10 and 11 in Ruskin's sale at Messrs. Christie's on 15th April 1869 (*Works*, XIII, p. 570; the latter is now in the Whitworth Art Gallery, Manchester). There are only a few water-colour studies of birds in the Turner Bequest, and these are of a later date than No. 78, and were executed mainly as colour studies. (See Ruskin's 1881 *Catalogue of the Drawings and Sketches by J. M. W. Turner R.A. at present exhibited at the National Gallery*, in *Works*, XIII, p. 370; and *Inventory*, No. CCLXIII, Nos. 340, 341, 358 and 359.) Exhibited: *English Drawings and Water Colors from British Collections*, Washington and New York, 1962, No. 85.

In her article 'Mr. Ruskin at Farnley' (in *The Nineteenth Century*, No. 178, April 1900, pp. 617–22), Edith Mary Fawkes described Ruskin's visit to Farnley in December, 1884. On Sunday, 14th December, 'he looked at the book of birds, which he had alluded to in the letter of 1852. They seemed to delight him. . . . I asked if Turner had painted many birds, and he answered, "Nowhere but at Farnley. He could only do them joyfully there!" '

79. (XVIII) *The Junction of the Greta and Tees at Rokeby.*
Water-colours over pencil, with considerable scratching out and some use of the brush handle; 290 : 414.
Collections: J. Dillon (Christie's Sale, 7th and 9th June 1856, lot 141, sold for £199); Ruskin.
Ruskin School Collection (Standard Series, No. 2; *Works*, XXI, p. 11, facing which is a misleading photogravure reproduction as plate XXV).
Date 1816–18. The '*Yorkshire 5*' Sketch Book (*Inventory*, No. CXLVIII), which was used on Turner's visit to Yorkshire in 1816, includes on folio 29a a rapid pencil sketch of the present composition. One of the loose sheets (K.) in the *Farnley and Related Subjects* drawings (*Inventory*, No. CLIV) has at the top of the *recto* very rough pencil jottings also outlining the present composition and inscribed, by the artist, *Greta*, at L., and *Tees*, at R. The present drawing was engraved on copper on a considerably reduced scale by J. Pye in 1819 as one of the plates for Whitaker's *History of Richmondshire*, for which Turner made all the drawings in 1817 and 1818 (*Rawlinson*, I, p. 95, No. 175, where the drawing is wrongly described as being in the possession of Mrs. Fordham). There were several reprints of the Richmondshire plates (in 1843, 1874 and 1891). Pye's steel engraving, also after Turner, of the

same subject, used as an illustration to the 1834 edition of *Scott's Poetical Works* (*Rawlinson*, II, p. 282, No. 509) is based on a different drawing.

Ruskin considered No. 79 the best of the Oxford Turner drawings (it had cost him 500 guineas; see note to No. 76 above, and *Works*, XXI, pp. 169–70). In his note in the *Catalogue of the Standard Series* (*loc. cit.*) he refers to it as 'a faultless example of Turner's work at the time when it is most exemplary. It will serve us for various illustrations as we advance in the study of landscape, but it may be well to note of it at once, that in the painting of the light falling on the surface of the Tees, and shining through the thicket above the Greta, it is an unrivalled example of chiaroscuro of the most subtle kind; — obtained by the slightest possible contrasts, and by consummate skill in the management of gradation. The rock and stone drawing is not less wonderful, and entirely good as a lesson in practice'. Ruskin made numerous other references to this drawing: in his *Inaugural Lecture* as Slade Professor (*Works*, XX, p. 38) he spoke of it as that among all his Turner drawings which he 'had least mind to part with' — a sentiment repeated in his notes to the catalogue of the 1878 Exhibition at the Fine Art Society (*Works*, XIII, p. 444). No. 79 is also mentioned in the *Lectures on Landscape* (*Works*, XXII, pp. 16 and 69), *The Eagle's Nest* (*Works*, XXII, p. 172), and the *Notes for the Lectures called 'Readings in "Modern Painters"'* (*Works*, XXII, p. 514), as well as in several other places (*Works*, XXXIX, p. 628).

80. (XX) *Sketch of Mackerel.*
 Water-colours over pencil; 224 : 287.
 Ruskin School Collection (Educational Series, No. 182; *Works*, XXI, p. 91).
 Date about 1820–30; the drawing is on Whatman Turkey Mill paper, dated 1818. Ruskin also owned two other studies of mackerel, which were shown as Nos. 106 and 107 in the 1878 Exhibition (*Works*, XIII, p. 469). In a letter to the artist Frederic (later Lord) Leighton, written in June 1863, Ruskin suggested a visit to Denmark Hill 'if it be but to look at some dashes in sepia by Reynolds [actually by Romney], and a couple of mackerel by Turner — which, being principals instead of accessories, I hope you will permit to be well done, though they're not as pretty as peacocks' (*Works* XXXVI, pp. 446–7). In introducing the similar 'Studies of Birds and Fish' in the 1881 *Catalogue of the Drawings and Sketches by J. M. W. Turner, R.A. at present exhibited at the National Gallery*, Ruskin wrote: 'These sketches . . . are all executed with a view mainly to colour, and, in colour, to its ultimate refinements, as in the grey down of the birds and the subdued iridescences of

the fish. There is no execution in water-colour comparable to them for combined rapidity, delicacy and precision — the artists of the world may be challenged to approach them' (*Works*, XIII, p. 370).

81. (XLVD) *Study of Fish*.
 Water-colours over pencil; 244 : 302.
 Ruskin School Collection (Educational Series, No. 181; *Works*, XXI, p. 91).
 Date about 1820–30. Ruskin used this drawing, which depicts John Dory, plaice, shrimps and other fish, as an illustration in the third lecture — *Likeness*, delivered on 1st December — in his course on *The Elementary Principles of Sculpture* given in Michaelmas Term 1870. These lectures were published in 1872 under the title *'Aratra Pentelici'*; No. 81 is compared to a Japanese ivory carving: 'Here is, indeed, a drawing by Turner, in which, with some fifty times the quantity of labour, and far more educated faculty of sight, the artist has expressed some qualities of lustre and colour which only very wise persons indeed would perceive in a John Dory; . . .' (*Works*, XX, p. 288; in the published version *Likeness* is Lecture No. IV.)

82. (XXII) *Scene on the Loire*.
 Body-colour and water-colours on blue-grey paper; 140 : 191.
 Ruskin School Collection (Standard Series, No. 3; *Works*, XXI, p. 12).
 Date 1826–30. An unpublished drawing from the *Rivers of France* series, which Ruskin retained for a few more years after his gift of other drawings from this series in 1861 (Nos. 29–51). In his *Catalogue of the Standard Series* (*loc. cit.*) Ruskin refers to No. 82 as 'a faultless example of Turner's later and most accomplished work'; and in the 1878 *Notes by Mr. Ruskin on his Drawings by Turner* (*Works*, XIII, p. 449) it is described as 'quite inestimable'. In his *Lectures on Landscape*, delivered at Oxford in 1871, the *Scene on the Loire* is named as 'the loveliest of all' the Loire Series, giving 'the warmth of a summer twilight with a tinge of colour on the grey paper so slight that it may be a question with some of you whether any is there. And I must beg you to observe, and receive as a rule without any exception, that whether colour be gay or sad, the value of it depends never on violence, but always on subtlety.' (*Works*, XXII, pp. 55–6.) In the preceding year, in his Inaugural Lecture as Slade Professor at Oxford (*Works*, XX, p. 38), Ruskin described No. 82 as 'very precious, being a faultless, and, I believe, unsurpassable example of water-colour painting'. Some thirteen years later in a lecture delivered in 1883 (subsequently published under the title *The Art of England*; *Works*, XXXIII,

p. 348), Ruskin showed a copy of this drawing by Alexander Macdonald: 'For my purpose to-day it is just as good as if I had brought the drawing itself. It is one of the Loire series, which the engravers could not attempt, because it was too lovely; or would not attempt, because there was, to their notion, nothing in it.' (The Macdonald copy was subsequently given by Ruskin to the Felstead Diocesan College, Banbury Road, Oxford; a weak copy is in the compiler's collection.)

83. (XLVIIE) *On the Rhine.*

Water-colours and pencil; 151 : 230 (there is a slight tear at the lower L. margin).

Inscribed by the artist, in pencil, at L., (?) *Luhen.*

Ruskin School Collection (Rudimentary Series, No. 129; *Works*, XXI, p. 208).

Date about 1840. It has not proved possible to identify the scene, of which Ruskin wrote in his 1878 *Catalogue of the Rudimentary Series* (*loc. cit.*): 'First beginning of a sketch in his great time, showing how his method of work remained the same from first to last. Travellers who know the Rhine will easily recognise the scene; though it is a little disguised by the white clouds left between the hills, and to the forms of which more attention has been paid than to those of the building. The scrawled writing in the distance is unintelligible, but, most likely, only a note of colour.'

This and the following drawing very probably belonged to the series of Rhine sketches of which nine were included as lots 24 to 32 in the sale of *Drawings and Sketches chiefly by J. M. W. Turner R.A., the Property of John Ruskin, Esq.*, held at Christie's on 15th April 1869 (*Works*, XIII, pp. 571 and 603). The two-sided sheet, *On the Rhine*, in the Forster Bequest at the Victoria and Albert Museum (*Catalogue of Water Colour Paintings*, 1927, p. 535; F. 103), has been identified as being one of these nine sketches; it is very close in style and technique to Nos. 83 and 84, and its size is almost exactly the same as that of the latter, which is the larger of these two.

84. (XL) *On the Rhine: looking over St. Goar to Katz, from Rheinfels.*

Water-colours over pencil; 181 : 237 (the extreme lower R. corner has been cut).

Ruskin School Collection (Rudimentary Series, No. 130; *Works*, XXI, p. 208).

Date about 1840. Turner travelled up the Rhine on his way to Venice in

August of that year. There are several sketches of Rheinfels, St. Goar and Katz in the '*Brussels up to Mannheim*' *Sketch Book* (*Inventory*, No. CCXCVI; dated 1837–40). The pencil drawing of the same view as the present on folios 41a and 42 of *The 'Rhine' Sketch Book* of 1817 (*Inventory*, No. CLXI) has mistakenly been considered as the basis of No. 84; in fact, it must have served as such for the water-colour of the same year in the well-known Rhine series formerly at Farnley Hall (A. J. Finberg, *Turner's Water-Colours at Farnley Hall*, n.d., No. 50, plate XXIX), and now in the Goyder Collection.

In his note on the present drawing in the 1878 manuscript catalogue of the Rudimentary Series (*Works, loc. cit.*) Ruskin wrote of it as follows: 'A study of the Rhine in Turner's finest manner. Nothing can possibly be more exemplary in the use of the simplest means, or in the arrangement of glowing colour and the tender depth of shadows that have no gloom in them. It should be copied by every student who can enjoy it.' The Editors of the *Works* were probably wrong in their tentative suggestion that this drawing was shown as No. 54 in the 1878 Exhibition of Ruskin's Turners (*loc. cit.*). See also the note to the preceding drawing (No. 83).

85. (XLVIIf) *Cloud and Sunlight at Sea.*
 Water-colours; 192 : 242.
 Ruskin School Collection (Educational Series, No. 293; *Works*, XXI, p. 101).
 Date about 1840; a very rapid and fluid water-colour study, obviously removed from a sketch-book.

86. (XLI) *Evening: Cloud on Mont Rigi, seen from Zug.*
 Water-colours; 218 : 267.
 Ruskin School Collection (Educational Series, No. 300; *Works*, XXI, p. 101).
 Date 1841 or 1842; described by Ruskin in the *Catalogue of the Educational Series* as 'Sketch, by Turner, for his own pleasure'. On folio 27 of the *Lake of Zug and Goldau Sketch Book* (*Inventory*, No. CCCXXXI) there is a very rapid pencil sketch of the same view of the Rigi, and there are several somewhat similar sketches of the mountain among the 'Miscellaneous' water-colours grouped in the *Inventory* under No. CCCLXIV (Nos. 150, 219 and 327).

Turner was in Switzerland each summer from 1841 to 1844, and in the Turner Bequest there are numerous sketch-books and water-colours dating from these visits. Turner also executed two small series of finished water-colours from some of these sketches, the full story of which is told by Ruskin

in the *Epilogue* of *Notes by Mr. Ruskin*, his catalogue of the 1878 Exhibition at the Fine Art Society's Galleries (*Works*, XIII, pp. 475–85). Three of the first (1842) series were views of the Rigi, and the mountain also features in a large number of the Swiss drawings of these years in the Turner Bequest. In his entry for one of these, *The Rigi at Sunset*, in the 1857 *Catalogue of the Turner Sketches in the National Gallery* (*Works*, XIII, p. 204, No. 35) Ruskin wrote: 'I cannot tell why Turner was so fond of the Mont Rigi, but there are seven or eight more studies of it among his sketches of this period.' Perhaps, however, Ruskin has given the reason for the large number of Turner's Mont Rigi drawings in the slightly earlier entry for *The Rigi at Dawn* (*loc. cit.*, p. 203, No. 31), which he described as 'seen from the windows of his inn, *La Cygne*'.

Copy after J. M. W. Turner.

87. (XLVH) *Arcades of St. Peter's, Rome.*
　　Pencil, heightened with white, on a grey preparation; 224 : 360.
　　Ruskin School Collection (Supplementary Cabinet, No. 179; *Works*, XXI, p. 306).
　　A faithful copy of *The Colonnade of St. Peter's*, folio 4 in the '*Rome: C. Studies' Sketch Book* (*Inventory*, No. CLXXXIX), dating from Turner's first visit to Italy in 1819. The mis-attribution of this copy to Turner himself was not due to Ruskin, but to Cook and Wedderburn, who in 1906 compiled the *Complete Catalogue of the Ruskin Art Collection* contained in Volume XXI of the *Works*. 'The Supplementary Cabinet' is there described (p. 305) as 'a cabinet which Ruskin placed in the School but did not fill. The frames . . . have recently been filled with Turner plates in the first half . . . and miscellaneous examples in the other'. The original drawing was included as No. 256 in Ruskin's 1881 *Catalogue of the Drawings and Sketches by J. M. W. Turner, R.A., at present exhibited at the National Gallery* (*Works*, XIII, p. 378).

Drawings from miscellaneous sources

88. (XLIIIA) *Craig-y-foel, Radnorshire.*

Water–colours over pencil, touched with the reed pen; 167 : 209.

Signed, boldly in ink, near lower R. corner, *W. Turner*.

Collection : Finch.

Bequeathed to the Taylor Institution by the Rev. Robert Finch in 1830; transferred in 1913.

Date 1792. The drawing is inscribed on the *verso* by a contemporary hand, in ink, *Drawing by Turner | at his 1st Visit to Hereford | on his way to Rayder & | . . . | 24 June 1792 | a present.* Below this is written, by the same hand, in pen, *1 Originale Sketch | W. M. Turner |* and, in pencil, perhaps by the artist, *near Rhaidder.* A smaller, more calligraphic hand has written, in ink, *Craggy Voyle in Breconshire | near the River Ellen*; and finally, below these inscriptions, in form of a subtraction sum, is written *1821 – 1792 = 29*, denoting that it was 29 years since the drawing was made.

No. 88 has long been wrongly identified as being a view of Crickhowell in Brecnockshire, due, no doubt, to a misinterpretation of the misleading inscription *Craggy Voyle etc.* This seems likely to denote the tiny hamlet of Craig-y-foel, on the River Elan, some four miles south-west of Rhayader in Radnorshire.

A. J. Finberg (*Life*, pp. 21–2) draws attention to No. 88 (wrongly identified as of Crickhowell) as showing 'traces of the influence of Edward Dayes', and continues, 'We know that Dayes exercised considerable influence over Turner during the next two or three years, but this is the first dated drawing known to us in which it is clearly recognizable'.

89. (XLIIB) *The Old Ashmolean with Scaffolding erected against its South Front.*

Pencil; 287 : 264.

Presented by Messrs. P. & D. Colnaghi in 1959.

Date about 1792–5; Turner paid several visits to Oxford during these years, and in style and technique No. 89 should be compared with various examples in

the Turner Bequest of his work in pencil at this time. Some use has been made of a ruler, especially in the doorway on R., which is considerably out of drawing.

It has proved impossible to discover any record of major alterations or repairs to the Old Ashmolean building in the last decade of the 18th century. The drawing, partially owing to the position of the scaffolding, fails to indicate the narrow wall and window (or windows) at the south-eastern corner of the building.

90. (I) *'The Remains of Abingdon Abbey now called Starve Castle Abingdon'.*
 Water-colours, with pen and black ink; 270 : 207.
 Signed, in ink, at lower R. corner, *W. Turner delin*, and inscribed with the title on the cart on L.
 Collection: Preston.
 Bequeathed by Mr. A. E. Preston, F.S.A., in 1942.
 Date about 1793. Finberg firmly dated this drawing 1789 (see Cotswold Gallery, *First Annual Exhibition of Water Colours by J. M. W. Turner, R.A., & other Masters of the English School*, 1923, No. 6; and correspondence in Departmental archives); comparison with some of the drawings dated about 1793 in the Turner Bequest (see especially *Inventory*, No. XIV, B), as well as the advanced style of the hand-writing, suggest the later date. The delicate colouring and confident use of the pen are far in advance of the somewhat clumsy handling typical of the water-colours of 1789 (see *Inventory*, No. III).

 No. 90 shows the back of the Checker of Abingdon Abbey, with its imposing 13th-century chimney. Before purchasing the drawing, A. E. Preston pointed out the absence of another chimney, shown in a drawing of about 1804 and definitely removed by 1819. (See letter dated 30th April 1923, in Departmental archives).

91. (V) *'Transept of Tintern Abbey, Monmouthshire'.*
 Water-colours over pencil, with pen and ink; 355 : 260.
 Inscribed (?signed), with pen, near R. lower corner : *Turner*.
 Collections: Moore; Miller.
 Purchased from the Magdalen College Fund in 1917.
 Both Bell (*Walpole Society*, V (1917), p. 77; reproduced pl. XXVII) and Finberg (*Life*, p. 458) definitely identify this drawing with one Turner exhibited at the Royal Academy in 1795 (No. 589). The former had previously suggested identifying No. 589 with a drawing lent by J. E. Taylor to the R.A.

Winter Exhibition of 1887 (No. 26), which now forms part of the R. W. Lloyd Bequest at the British Museum (1958–7–12–400 Royal); but Finberg (*Inventory*, p. 37), though failing to identify the view correctly and not realising that the Taylor–Lloyd drawing is of the same view as the present drawing (with some variations in detail especially in the figures and staffage), correctly suggested that it 'is probably not by Turner', and refuted Bell's hypothesis put forward in his *The Exhibited Works of Turner*, 1901 (p. 29). In the 1966 duplicated catalogue of *Turner Water-Colours from the R. W. Lloyd Bequest*, the Tintern drawing was, however, firmly attributed to Turner, and stated to have been exhibited at the R.A. in 1796 [sic]. At best the Lloyd version can be no more than a poor repetition of the drawing here under discussion. No. 91 is reproduced in *Tintern Abbey*, M.O.W. Official Guide Book, 1959, facing p. 18. Exhibited: Manchester, *Art Treasures*, 1857, No. 297 (p. 183).

Turner visited Tintern in 1792 (*Finberg, Life*, p. 21) and perhaps again in 1793, and there are several early drawings of Tintern in the Turner Bequest (*Inventory*, Nos. XII, A to E, and XXIII, A). None of these is related to the present composition, but two (Nos. XII, E and XXIII, A) bear a close relationship to a view looking towards the East Window, now at the Victoria and Albert Museum (No. 1683–1871), which Finberg identifies as the *Inside of Tintern Abbey, Monmouthshire*, shown as No. 402 at the Royal Academy in 1794 (*Inventory*, p. 37).

According to Bell (*Walpole Society, loc. cit.*) Turner's connection with James Moore seems to have been but remote and was 'confined to the purchase of the beautiful drawing of the *Transept of Tintern Abbey* from the Royal Academy Exhibition of 1795'. It was at the Exhibition of 1795 that Joseph Farington first noticed Turner's work (*Diary*, 4th June).

92. (XLIIH) *Coast View with Chalk Cliffs.*
 Blue and grey washes, over slight pencil indications; 150 : 375.
 Pierrepont Barnard Collection; bequeathed in 1934.
 Date about 1795; though feeble in execution the style of No. 92 is reminiscent of similar wash drawings in the '*Isle of Wight*' *Sketch Book* in the Turner Bequest (*Inventory*, No. XXIV). A drawing in the Whitworth Art Gallery, entitled *Cliffs at Dover* (presented by J. E. Taylor, 1892, No. D/86/1892), has previously been described as a replica of No. 92; this is not, in fact, the case, though the compositions are somewhat similar. It is possible that the present drawing represents a scene on the Isle of Wight.

93. (XLIIIF) *Chester Castle.*

Water-colours over slight pencil indications, with some pen and ink and scratching out; 153 : 216 (the drawing is somewhat faded and rubbed).

Presented, through the National Art-Collections Fund, by Mr. W. V. Paterson in 1943.

Date about 1805; the drawing is based on the pencil sketch on folio 51 of the *'Chester' Sketch Book* in the Turner Bequest (*Inventory*, No. LXXXII). It was engraved, on copper (s.s.), by W. Byrne for his *Britannia Depicta* (*Rawlinson*, I, p. 31, No. 71; II, p. 189). The plate is dated 24th January 1810.

Attributed to J. M. W. Turner

94. (XLVIIIE) *Corpus Christi and Merton College Chapel.*

Water-colours, touched with pen and ink; 363 : 441 (Imperial; the upper portion of the drawing is badly foxed).

Collection : G. C. Druce.

Deposited by the Department of Botany in 1939.

Date about 1795; the rendering of the stonework and roofs is rather more detailed than is normal with Turner except in his earliest years. The dark tones of No. 94, however, preclude a date earlier than about 1795.

Monro School Copy; formerly attributed to J. M. W. Turner

95. (XLVIIID) *A Villa between Florence and Bologna* (after J. R. Cozens).

Water-colours and pencil, with some scratching out; 179 : 233.

Collections : (?) Dr. Monro; Palgrave.

Presented by the Rev. F. M. T. Palgrave and Miss Annora Palgrave in 1941.

Date about 1794–8; copied from a drawing (no longer traceable) based on a sketch, inscribed *Between Florence & Bologna — Sep.ᵗ 28* [1783] / *a Villa*, on folio 22 of Vol. VI of the J. R. Cozens 'Beckford' sketch-books (see *Bell and Girtin*, p. 76, No. 403).

Despite considerable research and literature devoted to the subject in the last sixty years (see especially *Bell and Girtin*, pp. 20–3; and *Finberg, Life*, pp. 36–40), the problem of attributing individually the numerous drawings executed under the direction and influence of Dr. Thomas Monro, between about 1794 and 1798, has not yet been convincingly solved. The large number of such drawings in the Turner Bequest are listed in Vol. II of the *Inventory* in the *Appendix of Doubtful and Other Drawings* (pp. 1221–46).

The present drawing, and the three that follow it (Nos. 96–8), have all, in the past, been specifically attributed to Turner, but in no case is there documentary or stylistic proof of such an attribution. Furthermore, all four have been thought to originate from the collection of Dr. Monro, but there is no actual evidence for this provenance; none of them can be positively identified in the sale catalogue of the Monro Collection (Christie's, 26th–28th June and 1st–2nd July, 1833; *Bell and Girtin*, pp. 83–4). Finally Nos. 95–8 have all been described as copies after J. R. Cozens, but this is, in fact, certain only as regards the first two.

Monro School Copy; formerly attributed to J. M. W. Turner

96. (XLVIIIc) *'In the Grisons'* (after J. R. Cozens).
Water-colours over pencil, touched with pen and ink; 233 : 192.
Collections : (?) Dr. Monro; Barnard.
Pierrepont Barnard Collection; bequeathed in 1934.
Date about 1794–8; copy of a monochrome drawing, inscribed with the title as above, in the Lupton Collection at the City Art Gallery, Leeds (*Bell and Girtin*, p. 35, No. 46; and 'Watercolours by J. R. Cozens', in the *Leeds Art Calendar*, Vol. 8, No. 27 (1954), p. 12, No. 6). The present drawing had previously been considered to represent Marksburg, on the Rhine; the ruins are, in fact, the castle and church (since restored) of Castelmur. The execution of No. 96 is especially feeble and flat, and any idea of an attribution to Turner must be ruled out. See also note to No. 95 above.

Monro School Copy; formerly attributed to J. M. W. Turner

97. (XLVIIIb) *The Entrance to the Amphitheatre at Capua.*
Grey and blue washes over pencil; 326 : 450 (irregularly cut at R. margin).
Collections : (?) Dr. Monro; Dr. Pocock (of Brighton); H. W. Underdown; Anderson.
Presented, through the National Art-Collections Fund, by Mr. A. E. Anderson in 1931.
Date about 1794–8; probably copied from a drawing by J. R. Cozens, which has not been traced. No. 97 was the first of the *Five Turner Water-Colour Drawings* reproduced in a booklet issued by H. W. Underdown in 1923, with a request for 'any information or suggestion with regard to them'. All five appear to have been similar grey and blue wash copies, probably after Cozens. See also note to No. 95 above.

Monro School Copy; formerly attributed to J. M. W. Turner.

98. (XLVIIIA) *The Pyramid of Caius Cestius, Rome.*
Grey and blue washes, over pencil; 179 : 217.
Collections: (?) Dr. Monro; Barnard.
Pierrepont Barnard Collection; bequeathed in 1934.
Date about 1794–8; probably copied from a drawing by J. R. Cozens, which is no longer traceable. See note to No. 95 above.

Formerly attributed to J. M. W. Turner

99. (XLVIIIF) *Saltwood Castle, Kent.*
Water-colours and pencil; 144 : 203.
Collection: Weldon.
Bequeathed by Mrs. W. F. R. Weldon in 1937.
Inscribed on the back of the old mount, in a 19th-century hand, in ink, *Saltwood Castle / Kent / Turner RA*, and, in pencil, *Saltwood Castle / Kent* and *J.M.W.* preceding the ink *Turner*. The presence of the ruinous wall in the foreground denotes a date before 1798, for in the engraving by J. Baily after James Moore in *The Itinerant*, which is dated 1st September 1798, the wall is omitted.
Though clearly by an artist of the Dayes, Girtin, Turner circle of about 1795, the drawing is too weak to be attributed to Turner himself.

Formerly attributed to J. M. W. Turner

100. (XLVIIIG) *Parkland, Autumn.*
Water-colours, with scratching out; 168 : 282 (the drawing is considerably faded and rubbed).
Pierrepont Barnard Collection; bequeathed in 1934.
Though definitely not by Turner, No. 100 is fairly close in technique and style to some of his 'hot' water-colours of about 1796.

Formerly attributed to J. M. W. Turner

101. (XLVIIIH) *Landscape with a white Horse and Haystack.*
Water-colours over pencil, touched with pen and ink, and with scratching out; 236 : 349.
Collection: Adair.

Presented by Miss Helen Adair in 1949.

Date about 1795–1800; clearly the work of an amateur with a few touches, especially in the foreground, by an abler hand. No. 101 is perhaps the work of Turner's pupil, Julia Isabella Levina Bennet, Lady Gordon (1776–1867), by whom at least two drawings executed in 1797 in conjunction with Turner are recorded (see Paul Oppé, 'Talented Amateurs: Julia Gordon and her Circle', in *Country Life*, 8th July 1939, pp. 20–1, which was written at the time of an exhibition at the Brook Street Galleries, London; and Hilda F. Finberg, 'With Mr. Turner in 1797', in *The Burlington Magazine*, XCIX (1957), pp. 48–51, fig. 21). The present drawing is certainly more completely from the hand of the pupil than either of those discussed by Mr. Oppé or Mrs. Finberg. Much work remains to be done on Turner's activity as a drawing master, to which Chapter VIII of Thornbury's *Life* gives but a slender introduction.

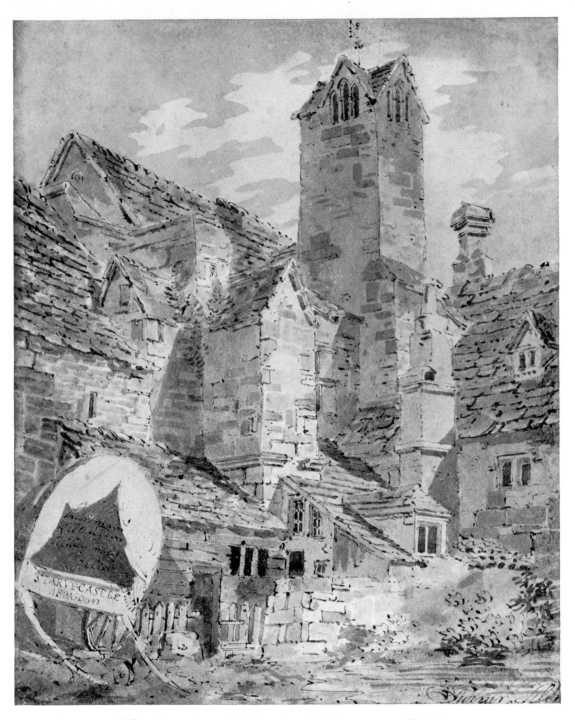

90. 'The Remains of Abingdon Abbey now called Starve
Castle Abingdon'. (270 : 207 mm.)

I

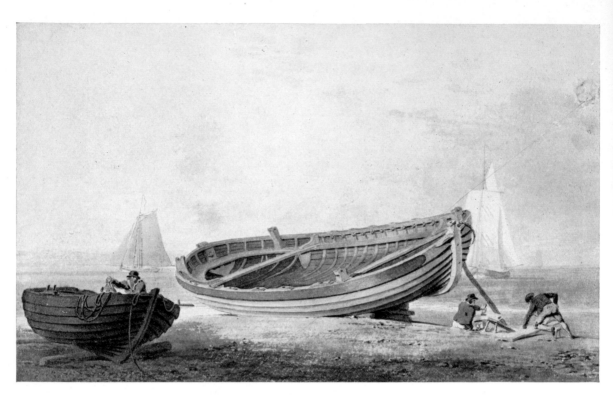

59. Boats on a Beach. (131 : 216 mm.)

60. The Ruined Abbey at Haddington. (175 : 203 mm.)

III

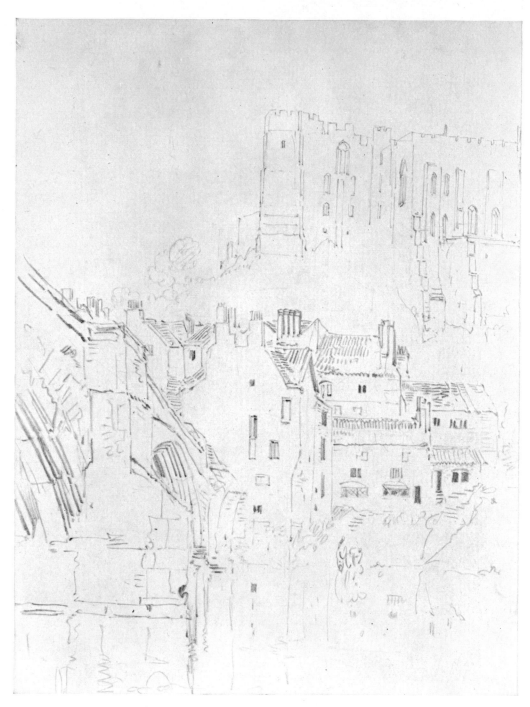

65. Durham Castle from across the River.
(*366 : 263* mm.)

IV

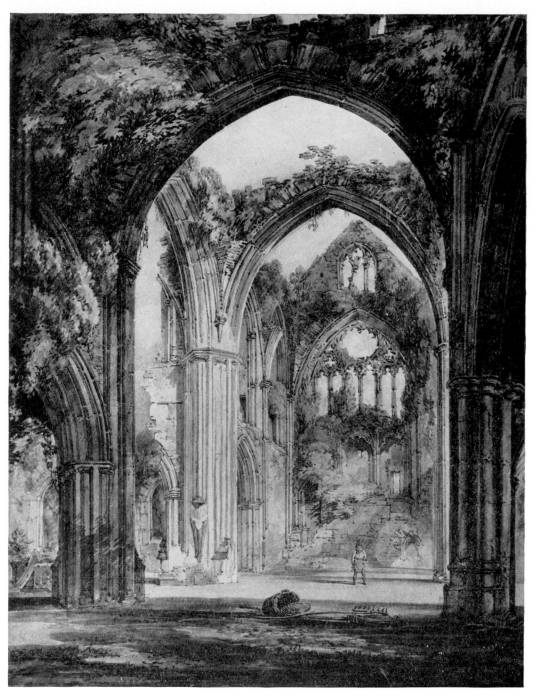

91. 'Transept of Tintern Abbey, Monmouthshire'.
(355 : 260 mm.)

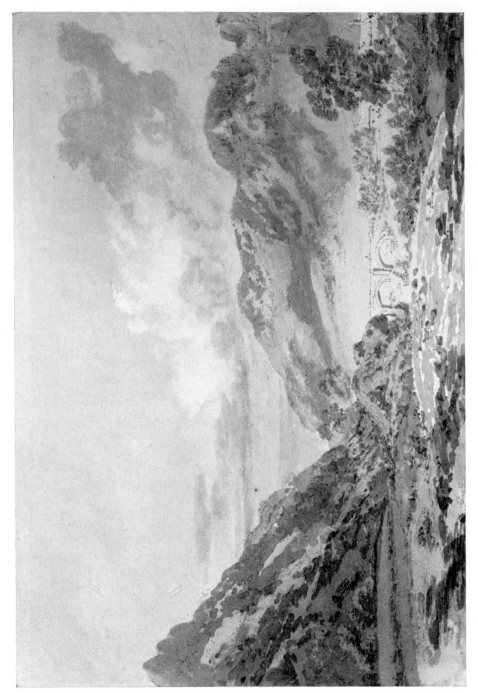

64. Mountain Landscape with a Bridge. (247 : 380 mm.)

VI

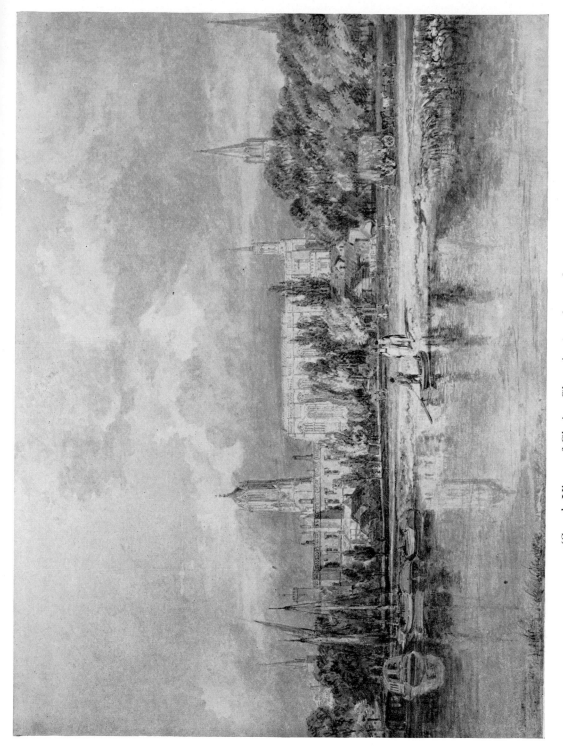

1. 'South View of Christ Church, &c. from the Meadows'.

(315 : 451 mm.)

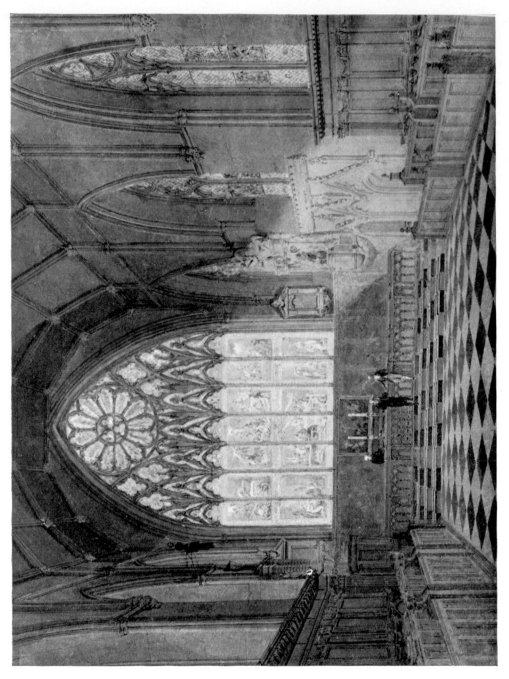

3. 'Inside View of the East end of Merton College Chapel'.
(318 : 444 mm.)

VIII

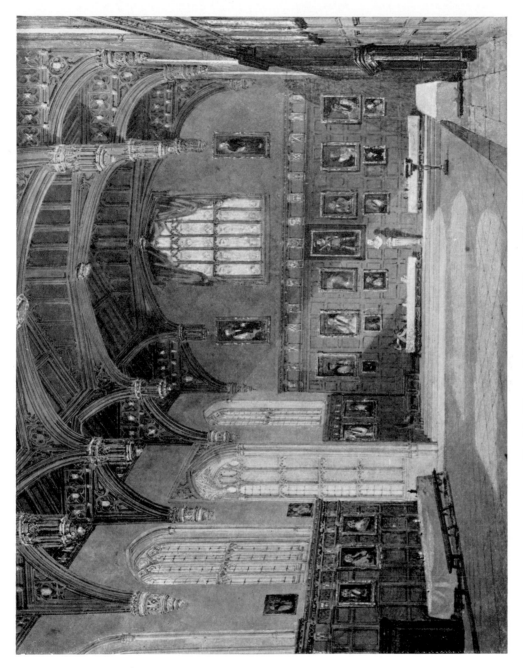

7. 'Inside View of the Hall of Christ Church'.
(329 : 448 mm.)

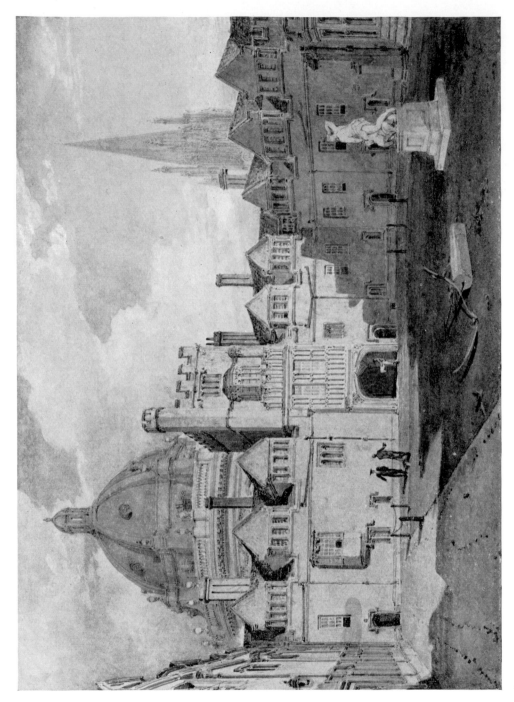

5. 'A View from the Inside of Brazen Nose College Quadrangle'.
(316 : 446 mm.)

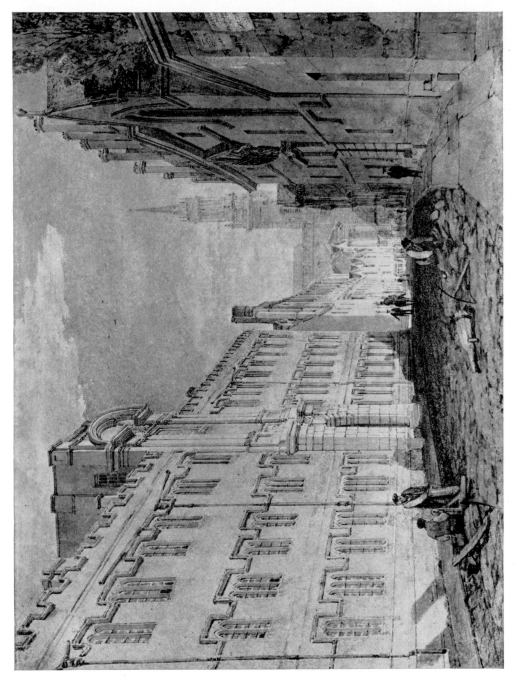

6. 'View of Exeter College, All Saints Church &c. from the Turl'.
(321 : 450 mm.)

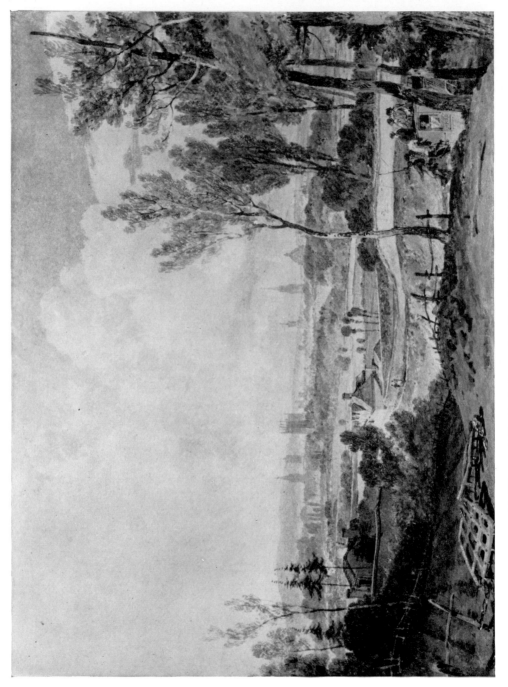

8. 'A View of Oxford from the South Side of Heddington [*sic.*] Hill'. (*316 : 448 mm.*)

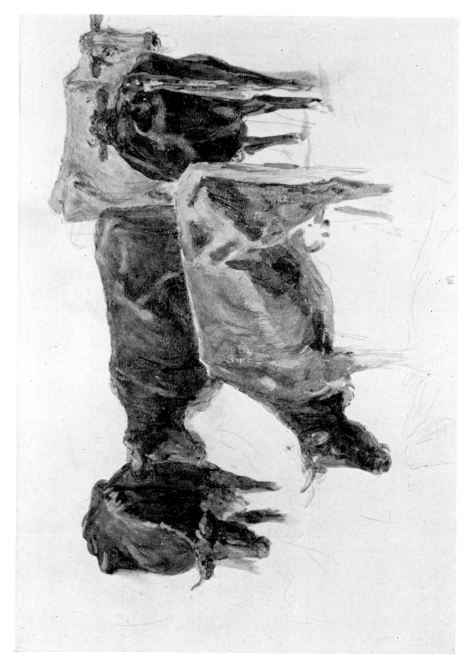

71. Study of a Group of Cows. (216 : 324 mm.)

XIII

12. Eton College from Fifteen Arch Bridge (on the Slough Road).

(206 : 270 mm.)

XIV

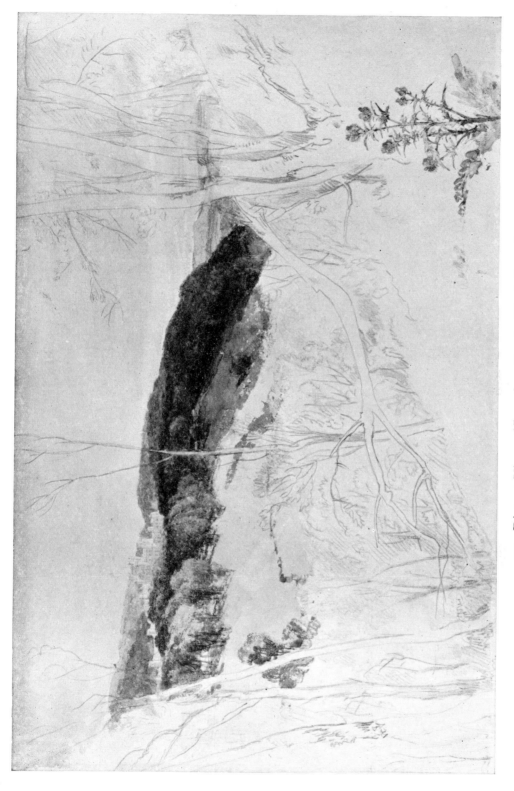

72. Distant View of Lowther Castle (Park Scene).
(224 : 352 mm.)

XV

75. Study of Trees. (226 : 336 mm.)

XVI

77. A Frontispiece (at Farnley Hall). (178 : 242 mm.)

79. The Junction of the Greta and Tees at Rokeby.
(290 : 414 mm.)

XVIII

24. 'Comb Martin' (Devonshire).
(146 : 232 mm.)

XIX

80. Sketch of Mackerel. (♀ 224 : ♀ 287 mm.)

23. (?) Yarmouth, Norfolk. (242 : 358 mm.)

XXI

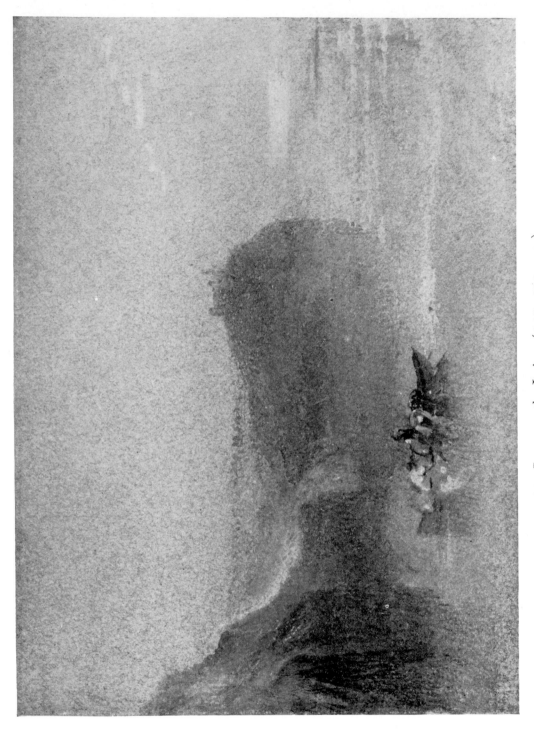

82. Scene on the Loire. (140 : 191 mm.).

XXII

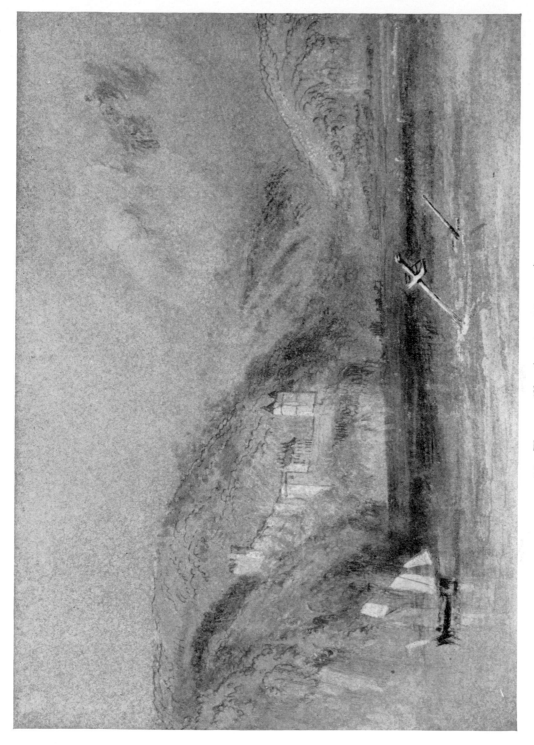

32. Tancarville. (155 : 188 mm.)

XXIII

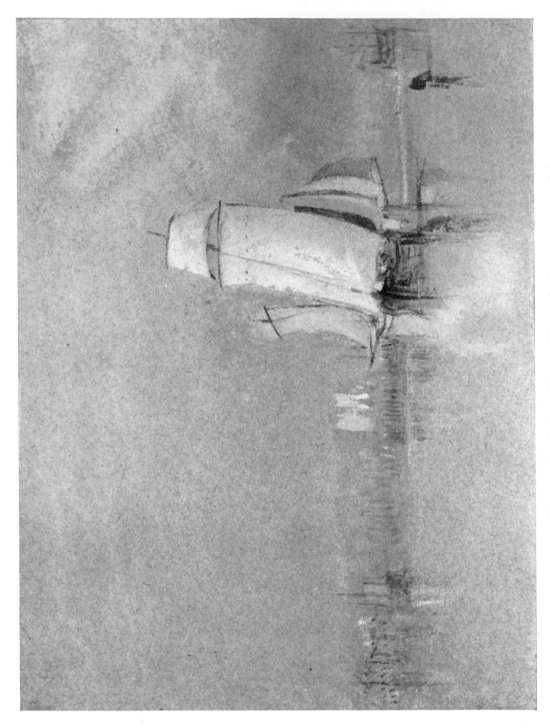

33. Calm on the Loire (? near Nantes). (138 : 188 mm.)

XXIV

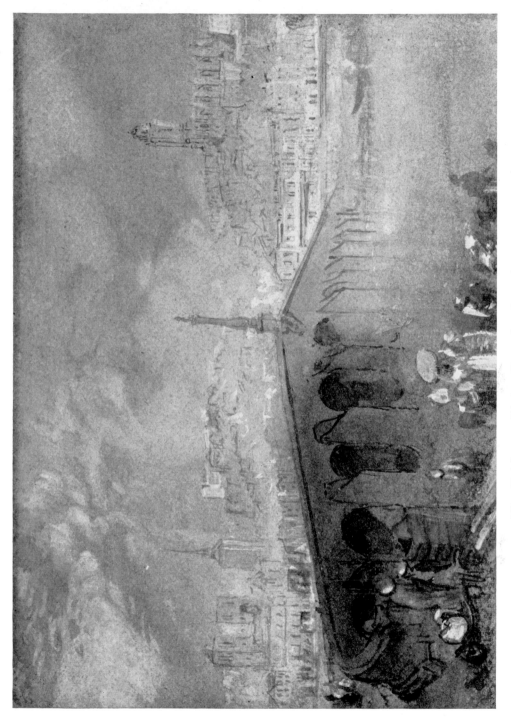

34. The Bridge at Blois : Fog clearing. (131 : 187 mm.)

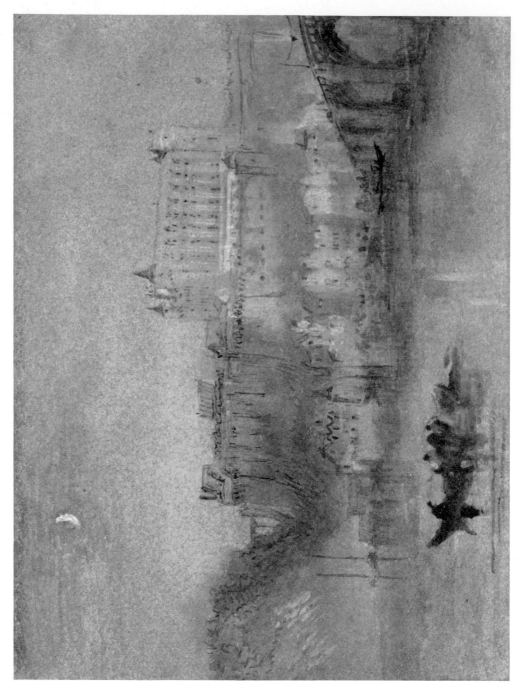

36. The Bridge and Château at Amboise. (134 : 187 mm.)

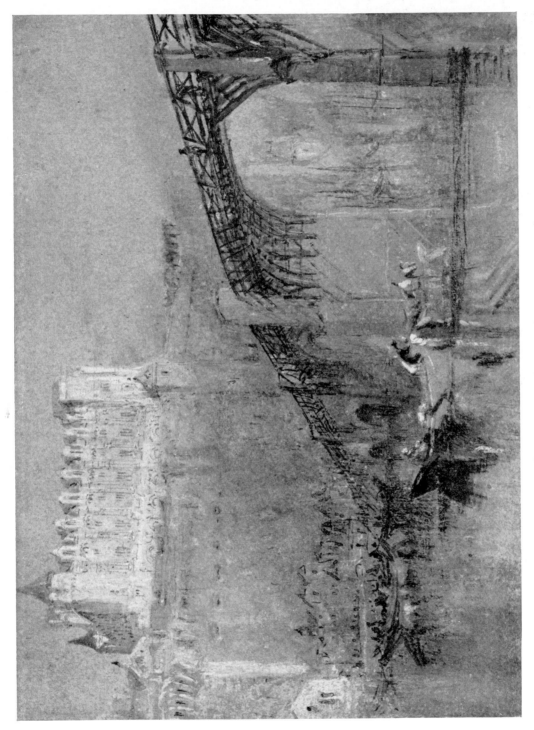

35. 'Château of Amboise'. (136 : 188 mm.)

27. Scene on the Meuse. (134 : 186 mm.)

XXVIII

44. 'Palace at Blois'. (130 : 185 mm.)

XXIX

41. 'Coteaux de Mauves'. (138 : 187 mm.)

XXX

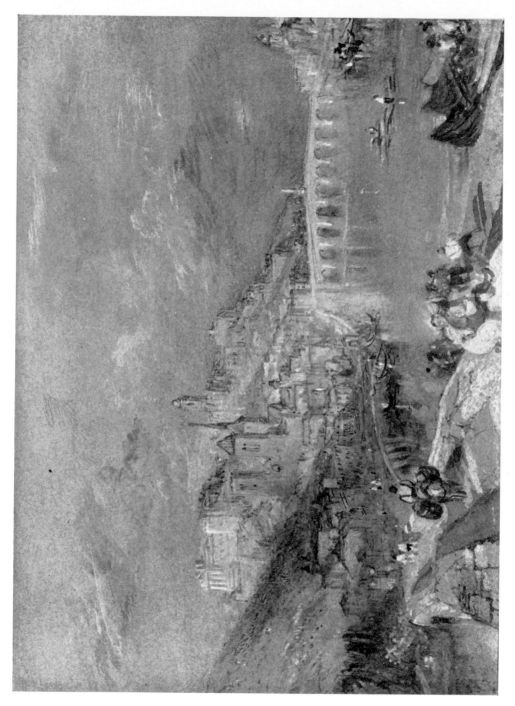

42. 'Blois'. (135 : 183 mm.)

XXXI

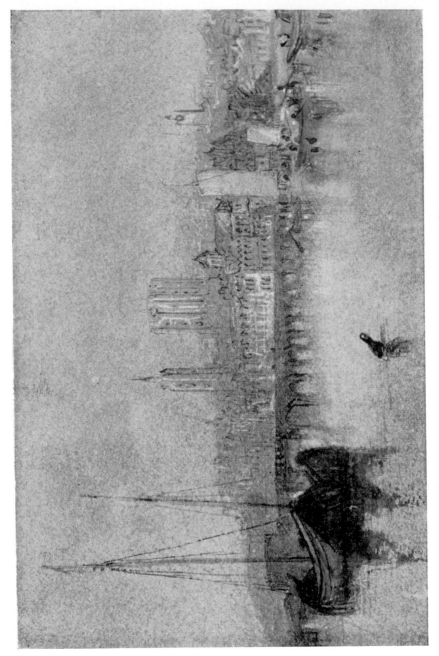

47. 'Beaugency'. (118 : 175 mm.)

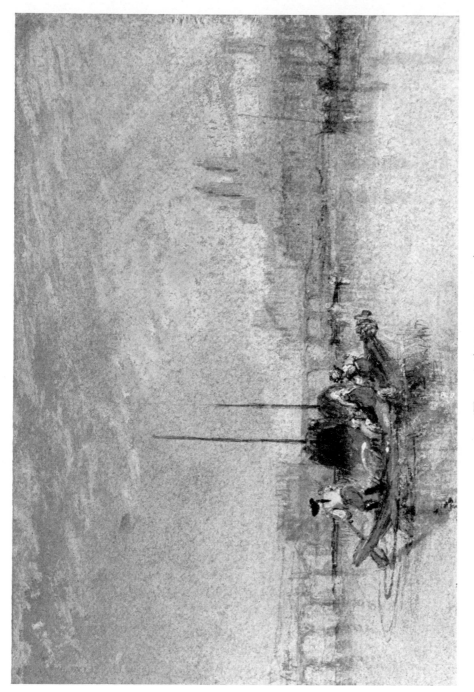

46. 'Tours'. (122 : 183 mm.)

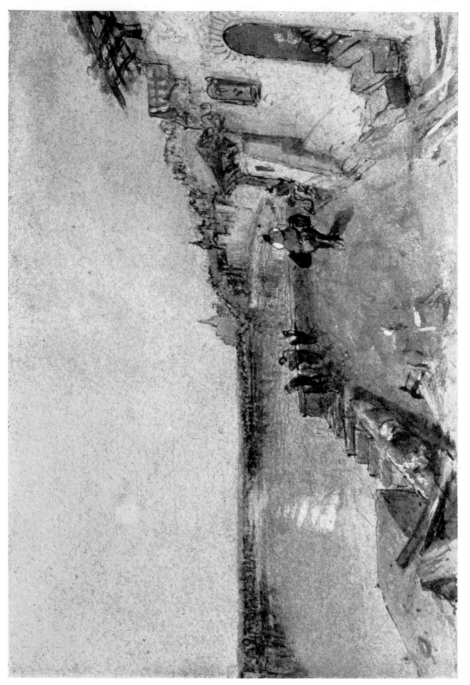

49. 'Rietz, near Saumur'. (124 : 181 mm.)

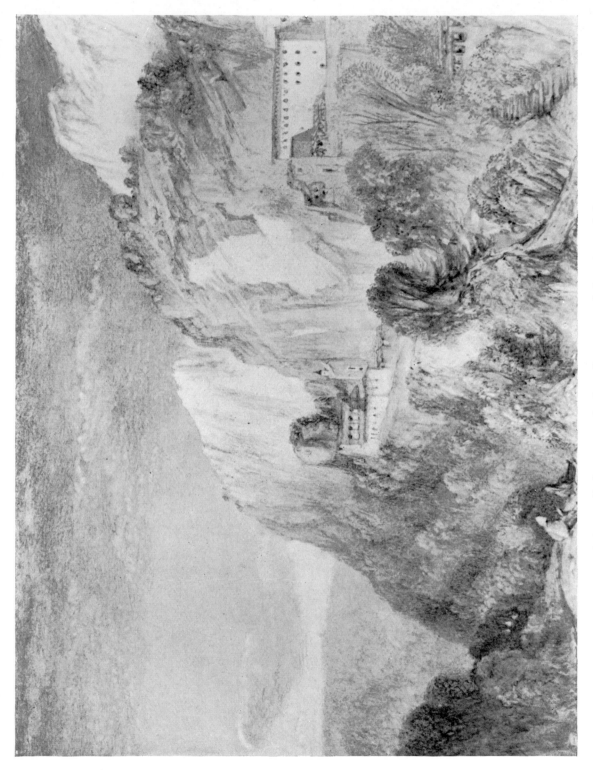

54. 'Mount Lebanon and the Convent of St. Antonio'. (146 : 200 mm.)

XXXV

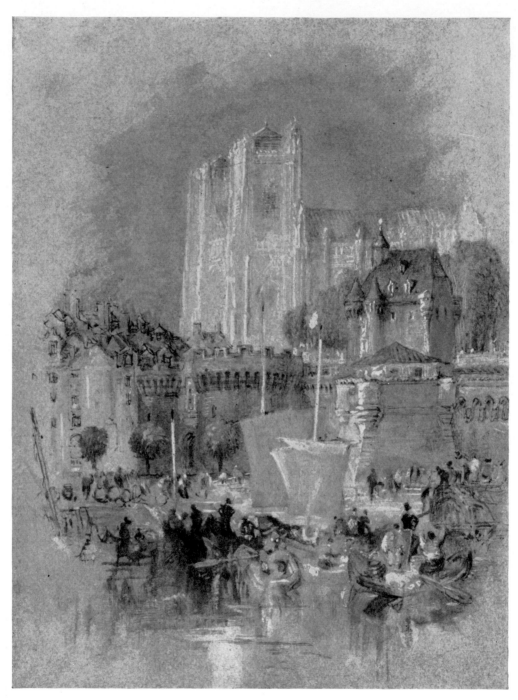

29. 'Nantes' (Vignette). (186 : 134 mm.)

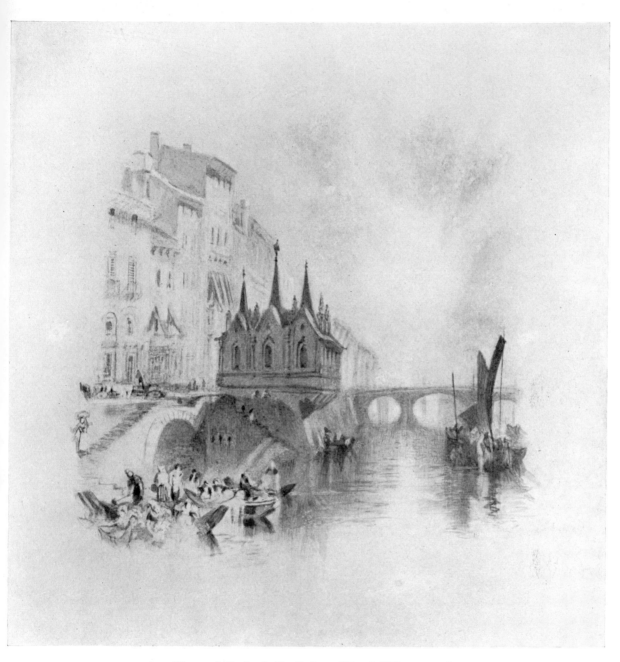

52. 'Santa Maria della Spina, Pisa' (Vignette).
(190 : 173 mm.)

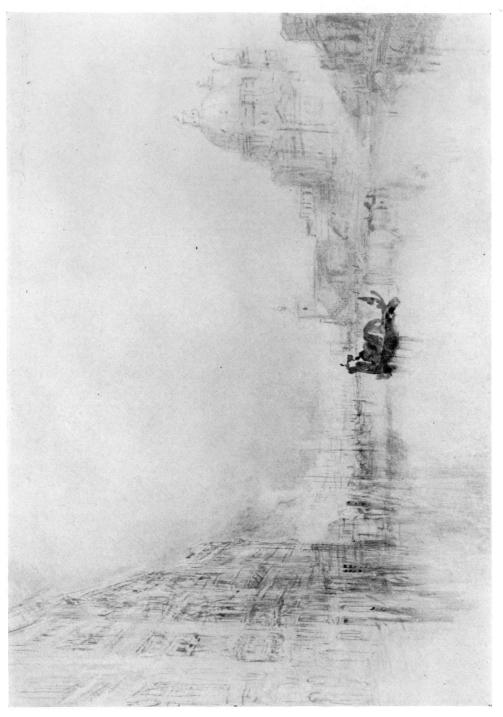

56. Venice : the Grand Canal. (215 : 315 mm.)

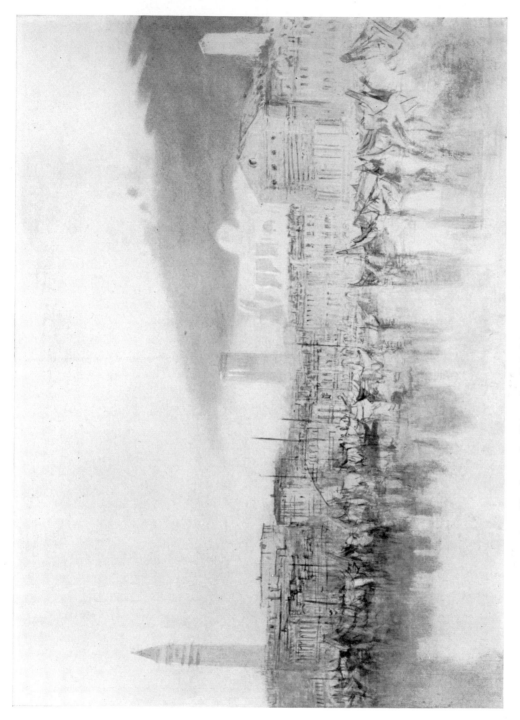

58. Venice : the Riva degli Schiavoni. (217 : 318 mm.)

XXXIX

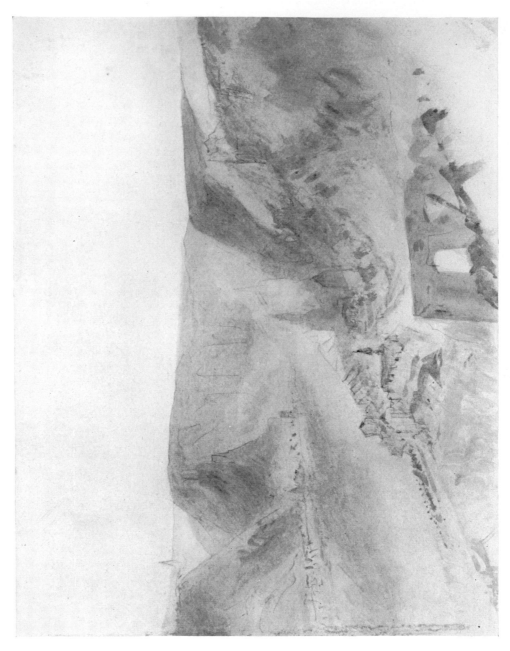

84. On the Rhine : looking over St. Goar to Katz, from Rheinfels.
(181 : 237 mm.)

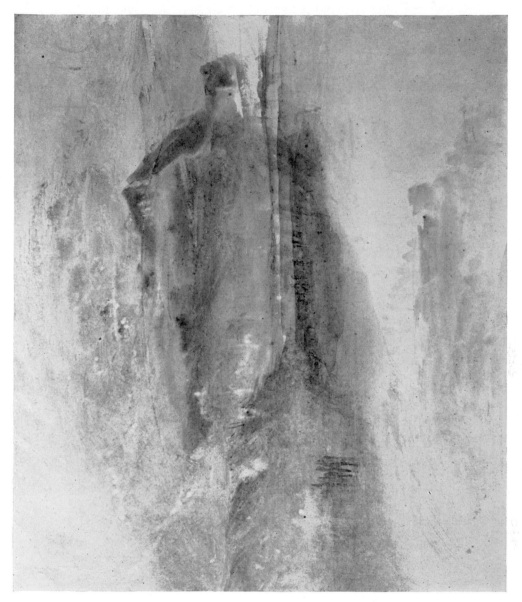

86. Evening : Cloud on Mont Rigi, seen from Zug.
(218 : 267 mm.)

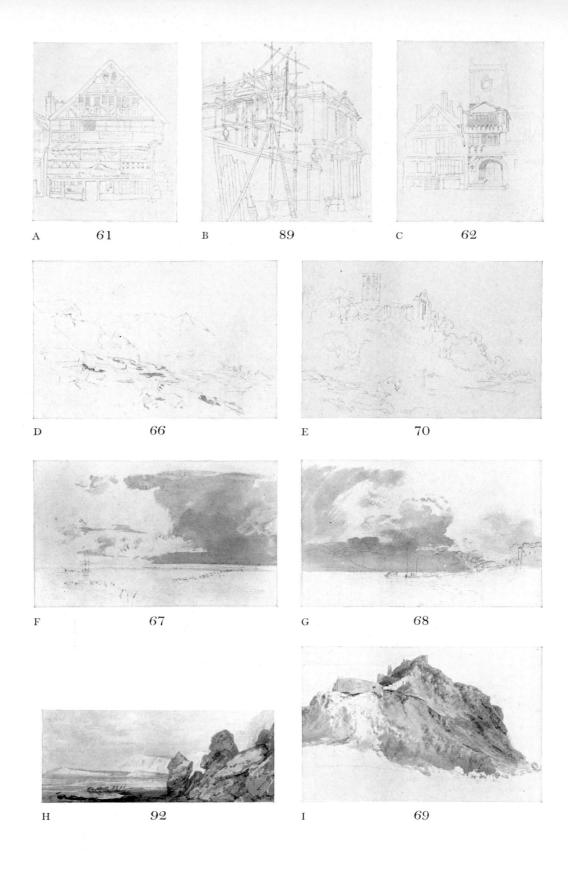

A 61 B 89 C 62

D 66 E 70

F 67 G 68

H 92 I 69

XLII

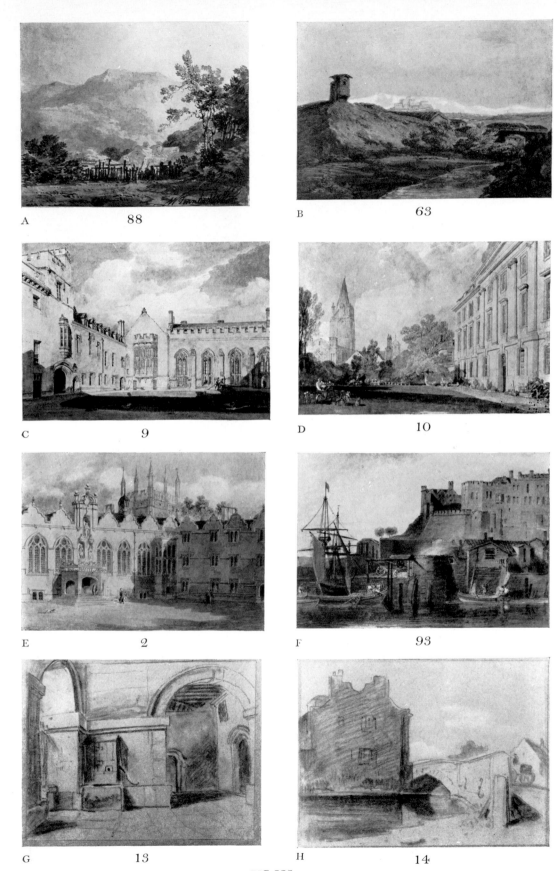

A 88 B 63

C 9 D 10

E 2 F 93

G 13 H 14

XLIII

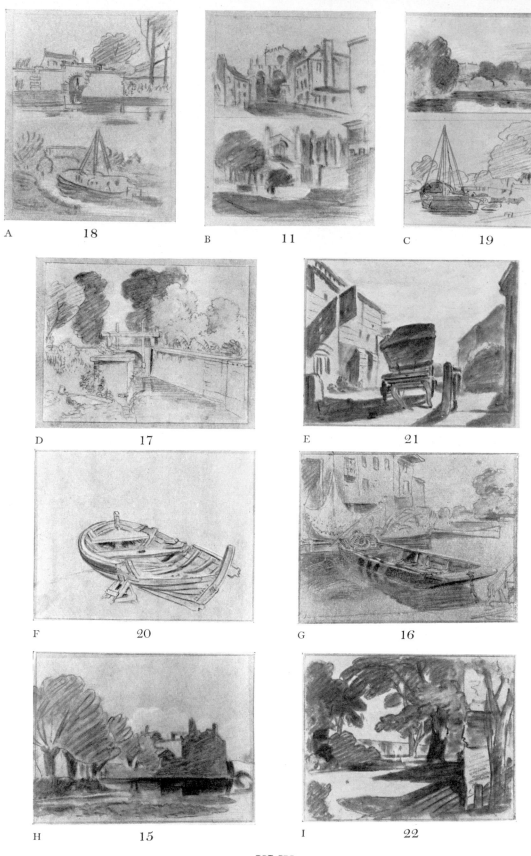

A 18

B 11

C 19

D 17

E 21

F 20

G 16

H 15

I 22

XLIV

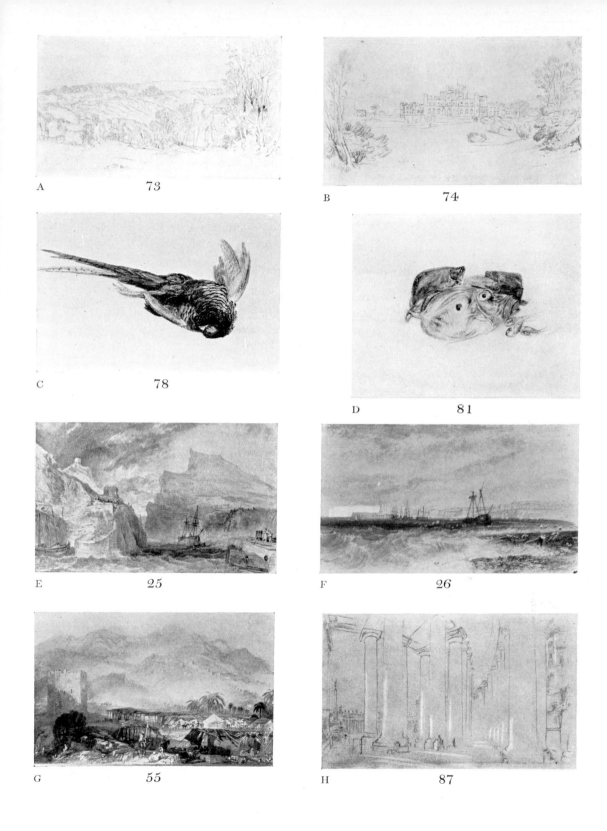

A 73

B 74

C 78

D 81

E 25

F 26

G 55

H 87

XLV

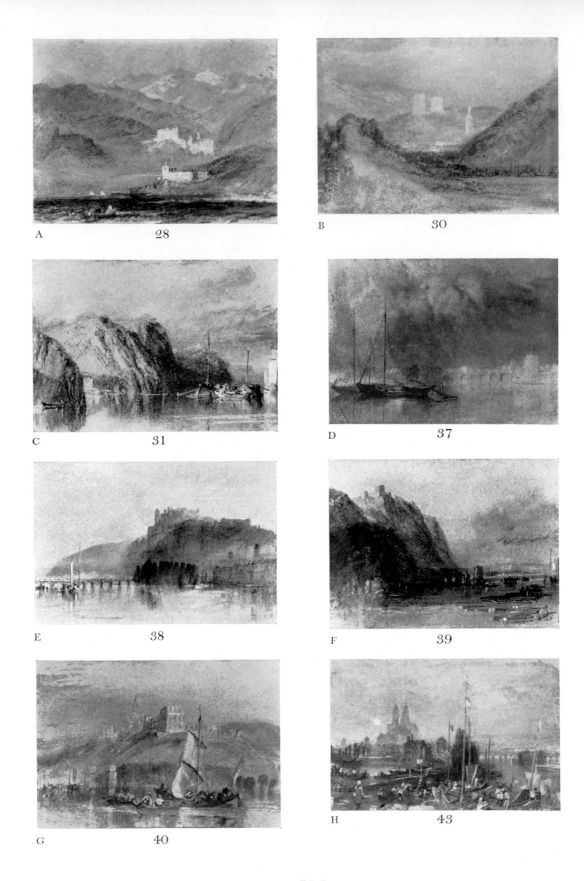

A 28 B 30

C 31 D 37

E 38 F 39

G 40 H 43

XLVI

A 45

B 48

C 51

D 53

E 83

F 85

XLVII

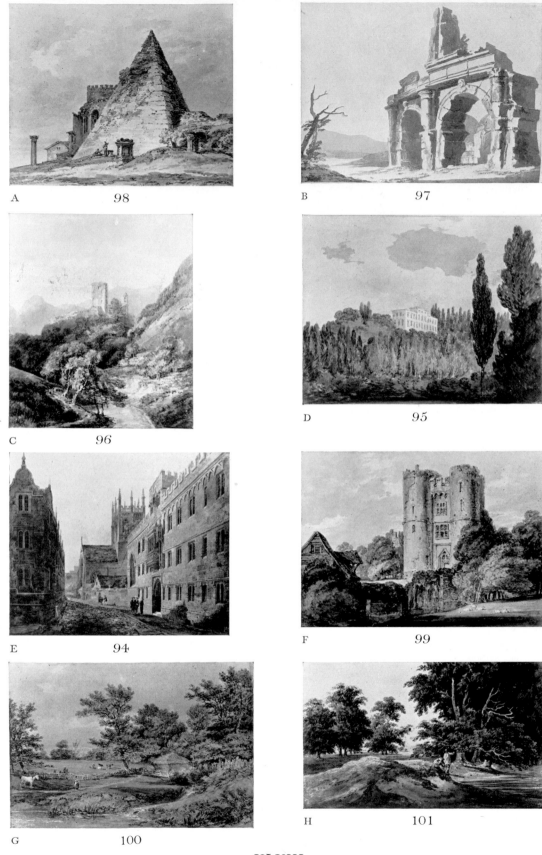

A 98

B 97

C 96

D 95

E 94

F 99

G 100

H 101

XLVIII